Making Sense of Recordings

Making Sense of Recordings

How Cognitive Processing of Recorded Sound Works

Mads Walther-Hansen

OXFORD
UNIVERSITY PRESS

Oxford University Press is a department of the University of Oxford. It furthers
the University's objective of excellence in research, scholarship, and education
by publishing worldwide. Oxford is a registered trade mark of Oxford University
Press in the UK and certain other countries.

Published in the United States of America by Oxford University Press
198 Madison Avenue, New York, NY 10016, United States of America.

© Oxford University Press 2020

Library of Congress Cataloging-in-Publication Data
Names: Walther-Hansen, Mads, author.
Title: Making sense of recordings: how cognitive processing of recorded sound works /
Mads Walther-Hansen.
Description: New York : Oxford University Press, 2020. |
Includes bibliographical references and index.
Identifiers: LCCN 2020012858 (print) | LCCN 2020012859 (ebook) |
ISBN 9780197533901 (hardback) | ISBN 9780197533918 (paperback) |
ISBN 9780197533932 (epub)
Subjects: LCSH: Sound recordings—Aesthetics. |
Sound recordings—Production and direction.
Classification: LCC ML3877 .H37 2020 (print) |
LCC ML3877 (ebook) | DDC 780.26/6—dc23
LC record available at https://lccn.loc.gov/2020012858
LC ebook record available at https://lccn.loc.gov/2020012859

1 3 5 7 9 8 6 4 2

Paperback printed by Marquis, Canada
Hardback printed by Bridgeport National Bindery, Inc., United States of America

Contents

Preface

The sonic qualities that emerge from aesthetic and technological decisions in the recording studio have a major impact on how music sounds, yet our ability to describe this impact on the listening experience is limited. Listeners often use very elaborate metaphors such as timbral and spatial characteristics when describing sound quality. There is, however, a prevalent belief that metaphors are vague and highly subjective and therefore unsuitable for academic and more exacting discussions of sound. *Making Sense of Recordings* challenges this assumption by showing how these metaphors are closely connected to our sonic experience and showing that they make sense within a larger historical context of technological developments and changing discourses of recorded sound.

Part I of the book starts by tracing written discourses of recorded sound, discussing the ways in which everyday listeners and audio professionals describe their experiences of sound in recorded music. The concept of the listener, as it is theorized here, relates both to the production and the reception sides of recorded music and assumes some sort of conscious evaluative process whereby people give meaning to their experiences. Listening is approached from a *quality-oriented viewpoint* concerned with embodied cognition and is conditioned by the specific listening situation and the specific purpose of listening. Building on cognitive sciences, ideas of embodied cognition, and recent studies in discourse analysis, the book then provides new theoretical and methodological approaches to sound perception and conceptualization with particular relevance to recorded music. The aim is not only to expand on existing histories of studio music technologies, from production to reproduction to reception, but also to provide analytical and practical tools to aid in the understanding and communication of sound discourse in the studio and beyond.

Part II of the book is an encyclopedia of metaphors often used to describe sound. The purpose is not to provide static definitions for each term but, rather, to propose ways in which the terms—as expressed in language—reflect cognitive processes. Sound descriptors are largely unstable at the level of language because many contextual factors influence the specific meaning of each term. However, there is "stability"—contingent on experience and on cultural as well as contextual factors—at the level of thought. Each entry in the

encyclopedia will serve to exemplify the theoretical framework outlined in Part I. These exemplifications will allow the reader to reason about and evaluate a number of central terms in different listening situations.

Making Sense of Recordings offers a new perspective on record production, music perception, and the aesthetics of recorded sound that will be of interest to anyone who cares to ask how recorded music sounds, why it sounds as it does, and how to describe the quality of this sound in language.

Acknowledgments

This book would not have been possible without the support of my colleague Mark Grimshaw-Aagaard, professor of music at Aalborg University, Denmark, who has read and commented on countless draft versions of this book. I am deeply grateful for his continuous encouragement.

Several colleagues and friends contributed input and feedback in the writing process. I am particularly indebted to present and former members of the Music and Sound Knowledge Group (MaSK) and to my students at Aalborg University, who challenged my assumptions and—on several occasions—made me revise my ideas. At Oxford University Press I thank commissioning editor Norm Hirschy and music editor Lauralee Yeary for believing in this project from the very first sketches to the final manuscript. Last but not least, I am grateful for the unconditional support and love of my wife Wilma and our daughters Lily and Esmaralda.

Introduction

Sound quality is notoriously difficult to describe in words. We come across these difficulties, for instance, when trying to verbalize the expressive qualities of our favorite music track, when evaluating the auditory characteristics of different loudspeakers in the hi-fi shop, or when trying to achieve a certain sound in the rehearsal room or in the recording studio. Often, we turn to terms of a metaphorical nature to describe the sound's quality such as *punchy, soft, fat, bright, hollow, organic, heavy,* or *cold.* This is only natural and, indeed, inevitable. Metaphors are prevalent in most descriptions of sound and provide one of the most fruitful entry points into an understanding of sound quality, yet the widespread use of metaphors becomes apparent only when we learn to connect linguistic expressions with the underlying cognitive metaphors (existing on the level of thought) from which they are derived. It is this connection that allows sounds to have characteristics or perform actions that do not prima facie belong to the auditory domain. Thus, this book does not treat metaphors as figures of speech according to traditional definitions; metaphors, rather, are the means whereby one makes sense of auditory experience.

In order to demonstrate how this understanding of metaphors is reflected in language, the following quotations describing sound quality have been taken from music reviews and sound engineering literature (metaphors in italics):

- This mic delivers that *silky smooth* sound quality with which the ribbon is associated. (Robjohns 2000, n.p.)
- The next section really *kicked in, full of life* and sounding *huge*, to create a *fitting end* to the track. (Gordon 2012, n.p.)
- [The editing] created a nice, *round* sound, as the *dull* thud of my inept hand slap became more like *pure* ringing tones. (Winer 2012, p. 285)
- [Benjamin John] Power often leans heavily on a *wash* of wave-like noise similar to what Brian Eno cultivated. (Neyland 2011, n.p.)
- The *sizzling* sound of music. (Dougherty 2009, n.p.)

Making Sense of Recordings. Mads Walther-Hansen, Oxford University Press (2020). © Oxford University Press.
DOI: 10.1093/oso/9780197533901.001.0001.

- I went for the *old* sound in his voice and got a great *big, warm* sound that also has a lot of presence. (Daniel Lanois on recording Bob Dylan, quoted in Zak 2001, p. 112)
- Many listeners preferred the *warm* sound of acoustic 78s to those made by the electrical process beginning in 1925. (M. Katz 2010, p. 192)
- The album's sound is similarly *mellow* and *rounded, warmed* by lovely piano and strings. (Green 2011, n.p.)
- The rest of the song alternates between *dark* and *light*, and finishes on the same near-silent acoustic note we met at the journey's beginning. (K. Kelly 2013, n.p.)
- If you have cheap equipment, you shouldn't make the mix too *bright* and *crispy* because it will show off any noise and distortion. With better equipment, you can often make your mixes *cleaner* and *clearer*. (Gibson 2005, p. 24)

Most people use metaphorical language instinctively when describing sound quality. Specific tracks, instruments, artists, music producers, or music technologies are said to have a characteristic sound, and these characteristics are articulated repeatedly in, for instance, music magazines and music radio programs as well as by music fans in everyday conversations. Still, we are seldom consciously aware of how we make sense of and articulate these characteristics. Skimming through texts dealing with recorded music reveals hundreds of different phrases that involve metaphors such as well-balanced sound, warm sound, gritty sound, crispy sound, round sound, dirty sound, colored sound, lifeless sound, open sound, hollow sound, honky sound, muddy sound, sticky sound, grainy sound, rough sound, ambient sound, short sound, heavy sound, layered sound, full sound, airy sound, and thin sound. Metaphors such as these might appear random and highly subjective, but what happens when we move beyond the mere linguistic features of these descriptions to examine how and why these particular metaphors emerge in the first place?

To start things off, I shall make a preliminary claim: Metaphors in descriptions of sound make sense and are used (consciously or unconsciously) because they closely represent the auditory experience. For this reason, they are indispensable tools for making sense of sounds' qualities. This claim is supported in much cognitive linguistic theory that takes communication and thought to be highly connected (Lakoff and Johnson 1980; Lakoff 1987; Johnson 1987; Gibbs 1994; Kövecses 2002; Fauconnier and Turner 2002), and it is closely tied to the notion of the *embodied mind*, a notion that can be traced back to Maurice Merleau-Ponty's (1945/2002) philosophy. Following the embodiment paradigm, linguistic metaphors are based on underlying cognitive metaphors that are deeply related to embodied experiences. These

embodied experiences—formed primarily through previous sensorimotor experiences—structure sense-making and makes possible a meaningful link between, for instance, being warm, touching a soft surface, watching a round object, and listening to music with a warm, soft, dark, thin, rough, smooth, big, hollow, or round sound. Indeed, most sound descriptors are transferred from either the tactile or the visual domain (or a combination of both). I deal with cross-sensory mappings from the tactile and the visual domains more thoroughly in chapter 3.

At this point it is worthwhile to qualify the notion that cognitive metaphors emerge primarily from previous sensorimotor experiences. Although such experiences are probably the most significant aspect in the forming of cognitive metaphors, cultural understanding and learned concepts ("invented" metaphors) influence the forming of these metaphors. Recent research has shown that novel definitions of concepts (for instance, a new scientific definition of sound) shape sensorimotor processing (Beilock 2009; Slepian and Ambady 2014). Such findings support the idea put forward in this book that cognitive metaphors—used to process auditory experience—do not emerge solely from everyday experiences. Sonic concepts taught from textbooks, reflected in advertisements for audio technology, learned from operating audio equipment, and so on (that do not necessarily correspond to previous sensorimotor experiences in other domains) often come to influence the forming of the embodied cognitive structures that are activated in auditory experiences. Figure I.1 outlines the main processes involved in the forming of cognitive metaphors.

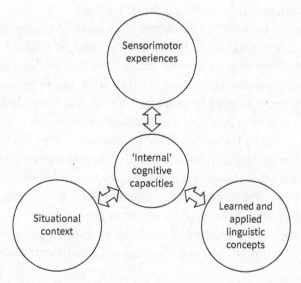

Figure I.1 Elements contributing to the forming of cognitive capacities

Listening

The motivation for writing this book grew from discussions with colleagues and students in musicology departments who find that metaphors have little or no value in any serious academic analysis of music or sound. Linguistic metaphors, it is commonly believed, are merely ornaments that are primarily subjective and often randomly picked. For the same reason, I find that scholars and students who do, in fact, use metaphors in their musical analyses have a hard time justifying this choice. The aim of this book is to provide the theoretical and practical evidence for this justification. This is achieved through examinations of the use of metaphors in the discourse of sound and by scrutinizing the cognitive processes that govern our experiences of sound. I believe that the language we use to describe sound quality and music holds the key to understanding how our cognitive system works in the act of listening. This book, then, is less about the acoustic properties of sound itself than it is about the operations that our cognitive apparatuses perform in order for us to understand and make sense of sound.

An important starting question is, how does one justify one's own listening experience as analytically valid? Usually there is a somewhat sharp distinction between music reviews (written by journalists) and music analyses (performed by musicologists), and the borderlines between these types of writings are usually drawn (at least, from the point of view of the musicologists) with reference to the formers' being merely subjective and the latters' being situated within a specific academic tradition and thus rendered valid or not with reference to this particular tradition.

In this book, listening is theorized in relation to different listening contexts (e.g., cultural, social, or historical) and in relation to specific listening situations (e.g., everyday music listening or interactive music listening when producing music). I deal with listening and listening discourses in greater detail in chapters 1 and 2, but I shall briefly outline here how I conceive of listening and the listener throughout the book. My approach to listening is closely related to Ola Stockfelt's (1993) concept of *adequate listening*. Stockfelt argues that listening is shaped by the way we choose to listen. This choice is not free, however, but is closely conditioned by the situation. Music listening is characterized by a certain aesthetic attitude toward sound. Even when music is strongly connected to social identification, music listening and music evaluation are processes whereby people give meaning to their experience. Modes of listening are normative

(in relation to genres, subcultures, and so on), and the adequate mode of listening in a specific situation is something learned by engaging in everyday activities (e.g., listening to everyday sounds in the street, listening to music in a shop or at home, or listening to music while being asked to evaluate it). This leads me to three overall aspects that condition listening as it is theorized here:

- Music listening and descriptions of music are always performed in a context.
- Music listening is always shaped by listening competencies and discourses of sound.
- Music listening is a means of declaring who you are (to yourself and others), and public discourses of music are, therefore, closely tied to processes whereby listeners distinguish themselves from other listeners.

Metaphors as Analytic and Practical Tools

In arguing that the use of metaphors should not be treated with snobbery and disdain in the academic world, I aim to demonstrate how we can actively use metaphors as tools for better understanding and communicating the sound quality of recordings in the process of listening and in the process of recording and editing recorded sound. By referring to using tools, I imply that we can take control of the metaphors that are already working in the background of our cognitive system and that this control will allow us to achieve different communicative purposes. We can, for instance, think of metaphors as tools for performing musical analyses, taking listening tests, or simply obtaining greater self-awareness about why a music track affected us in a particular way. Metaphors have the potential to be used as analytical tools, and this potential may be unleashed if we come to understand better the function of metaphors in the evaluation of sound quality. In order to do this, we must attempt to move beyond the largely unconscious use of metaphors to a more conscious, or at least reflective, use.

In some parts of the audio industry metaphors already have a tool-like status. Developers of hi-fi equipment, for instance, make conscious use of metaphors to evaluate and tweak the sound of their products and, later, to advertise their sonic characteristics. In *The Semantic Space of Sounds: Lexicon of Sound-Describing Words*, Torben Holm Pedersen (2008) of the Danish sound

evaluation firm Delta Lab has systematized these sound metaphors for use in tests of recorded sound and playback technologies. The idea is to provide an inclusive list of words (the lexicon contains 621 sound descriptors in English) that may be developed and used as tools for "transferring information" in audio evaluations. The end goal, for Pedersen, is to reach a certain degree of objectivity in listening tests. In order to obtain such an objective evaluation, testers should, according to Pedersen, learn to use descriptors correctly in order to relate them as closely as possible to the physical dimensions of sound and in order to avoid variations in term definitions across testers.

This is, in many ways, a sensible goal that mirrors the objective of many sound engineering handbooks, which often provide bar charts for descriptions of sound quality such as specific frequency ranges (e.g., B. Katz 2002; Izhaki 2008). What Pedersen's lexicon and the bar charts in sound engineering handbooks do not tell us, however—and this is my main objection to this method—is what made the listed descriptors potentially useful in the first place. If the sole goal is to correlate descriptors with physical parameters, we could, at least in theory, simply invent terms and teach a group of people to use them correctly. The questions remain: Why is warmth a good descriptor for a boost in frequencies of about 250–500 Hz? And why is the sensation of darkness typically produced by the low frequency content of the sound? The quest for more objectivity in sound descriptions is, by and large, not concerned with such questions, nor is it concerned with naturally occurring meaning in any systematic way. To put it bluntly, in the great majority of books about sound analysis or evaluation, the links between the cognitive basis of the words and their learned meanings are largely erased. One of the main objectives of this book is to restore this link.

The Rationale for, and Trouble with, Objective Sound Terminology

So, what is wrong with aiming for an objective terminology with which to describe sound quality? Despite my disagreements with an objectivist model of sound description, one may have good reasons for trying to build such a model. The idea is usually to make perceptual attributes of sound correlate more consistently with physical (measurable) parameters of sound. It is believed that we may only assess and compare the experiences of different users if they have the same definitions for the terminology they use to describe their experiences (e.g., Bech and Zacharov 2006). In this way, objectivist accounts are seen as safeguards against subjectivity.

The focus on objective measurement is also a common reason—a wrong reason, I think—for the widespread attempts to avoid the use of metaphorical descriptions of sound. For instance, in his book about technical ear training for sound engineers, Jason Corey addresses some of the problems with describing sound quality using metaphors:

> If an engineer uses words such as *bright* or *muddy* to describe the quality of a sound, it is not clear exactly what physical characteristics are responsible for a particular subjective quality; it could be specific frequencies, resonances, dynamics processing, artificial reverberation, or some combination of all of these and more. There is no label on an equalizer indicating how to affect these subjective parameters. Likewise, subjective descriptions by their nature are not always consistent from person to person or across situations. (2010, p. 9)

The key problem Corey addresses is the lack of a specific link between a particular term and a specific sound-editing action. If, for instance, a music producer asks a sound engineer to add warmth to the mix, the sound engineer may not know exactly which task to perform because *warmth* does not designate a specific action. Warmth is believed to be a subjective metaphor and, unhappily, there is no warmth fader on the mixing desk.

My objection is that metaphors are always already there. They are the means by which we make sense of what we perceive and are what allow us to respond meaningfully. If we attempt to avoid metaphors, we may lose the essence of the auditory experience. For the same reason, Corey fails in his effort to avoid metaphors. In fact, his book is full of metaphorical expressions such as "the vocal timbre has a warm yet slightly gritty sound" (p. 145), "the bass line is punchy and articulate" (p. 145), and "the round, full, smooth sound of the bass" (p. 147). Of course, Corey is not completely mistaken in his view of metaphors, insofar as we can never know for sure the exact meaning of people's descriptions and we will never be consciously aware of every aspect of how we experience sound—that goes for all communication. But the unwillingness to take metaphors seriously leads nowhere. By taking a more positive stance toward metaphors and consciously acknowledging how we use them, we may highlight aspects of a sound's quality that would otherwise be neglected. Metaphors enable us to talk about phenomena that lack terms to describe them in any literal sense. There simply is no non-metaphoric expression for a warm sound or a polished track, although many scholars refuse to admit this fact. Therefore, if we want to regain some order in the otherwise messy sensations of sound, we should look to the metaphor.

Conceptual Mapping

We may characterize our metaphorical system as something that operates in the background of our cognitive system and that provides something for experiences to *fit* into. The most basic principle in this operation is usually called *conceptual mapping*. This principle is, in later chapters, tied to related ideas about how the mind structures thinking, reasoning, and action, but, for now, a broad definition of conceptual mapping will serve to illustrate the key idea.

Metaphorical terms or phrases might hold truth about the world precisely because they fit into a larger conceptual system that arises from shared embodied experiences. Some of these experiences—such as having a body or being exposed to gravity—are seen as primary and therefore are more likely to be universal, whereas other embodied experiences are seen as more elaborate and culturally determined. Whether cognitive metaphors are universal or culturally framed, they are prerequisites for mutual understanding of metaphorical communication and are some of the main tools we use to create meaning.

Conceptual mapping is the process in which one domain (i.e., the experience of one phenomenon) is understood in terms of another domain (i.e., a previously experienced event, thing, bodily action, and so on). A domain may be characterized as a coherent part of our experience often framed by specific concepts. Moving, food, ideas, cooking, weather, balls, objects, anger, and feelings are all conceptual domains. As we can see from only this small number of examples, domains work on different levels of experience and may have different degrees of specificity. A ball and anger are more delineated and more specific domains than are objects and feelings. Also, and more important, some domains are considered concrete, whereas others are considered abstract. Sound quality (i.e., the timbral characteristics of the sound as it emerges in experience, rather than the characteristics of the sound source or the physical properties of the sound wave), for instance, is often considered a more abstract domain than, for instance, animals in that the latter has a more clearly delineated structure. We can see animals, touch them, smell them, and—if used as food—taste them, and they have a number of attributes that are easily describable (e.g., their shape, color, behavior, and location). We cannot point to the characteristics of perceived sound quality (at least, before we make a graphical representation of it), it has no physical shape, it does not perform actions other than those determined by physics, and it has no specific location distinct from the location of its source.

So, how do we make sense of the timbral qualities of sounds when these qualities have no clear perceptual form and often no clearly delineated spatial

location? In order to answer this question we can look to language. Here, we find that *sound quality* is often understood by mapping elements from the more concrete domain of animate or concrete things onto the more abstract domain of sound quality (other mappings are discussed in later chapters). We say that sounds are heavy, round, big, or rough, and we may report that the sound hit us in the face or that we shape the sound. All of these linguistic expressions are governed by the cognitive metaphor SOUNDS AS PHYSICAL OBJECTS (see Walther-Hansen 2014).[1] This example illustrates the basic principle of conceptual mapping. By borrowing terms from more delineated domains, conceptual mapping helps us create a language for phenomena for which we have no or few linguistic concepts. Usually the mapping goes from a more concrete domain, also known as the *source domain*, to a more abstract domain, also known as the *target domain*. In the cognitive metaphor SOUNDS AS PHYSICAL OBJECTS, physical objects are the source domain and sound quality is the target domain. Furthermore, we often characterize recordings as *containers* holding these objects. We say that sounds are *in* the track, they may *fill* the track, they may *clash* or *mask* each other, or they may *come out clearly* or appear more *tucked in*. These fictional citations point to the slightly more elaborate cognitive metaphor RECORDED SOUNDS AS PHYSICAL OBJECTS IN A CONTAINER.

The basic notion of conceptual mapping has inspired a number of musicologists. Lawrence Zbikowski's book *Conceptualizing Music* (2002), focusing exclusively on notation-based music, presents perhaps the most thorough theory of conceptual models in music. Focusing primarily on spatial features such as horizontal musical motion and the vertical distribution of pitches, Zbikowski finds that musical apprehension is governed by a large system of metaphors and that these, therefore, should serve as the basis for musical analysis. In this sense, Zbikowski's aims are comparable to the aim of this book, although it focuses on a different set of musical parameters.[2]

The cognitive structure of sound quality is mentioned in several studies (see, e.g., Théberge 1997; Budd 2003). Rolf Inge Godøy (2010) and Mark Leman (2010) have performed studies in gestural rendering of sound shapes in which they link different sound qualities with specific spontaneous gestures. Several scholars have built on the works of Leonard Talmy (1981, 1988) and the belief that force structures (a semantic category that describes how elements of perception, with an inherent force tendency, interact with each other) are central to cognition: Janna Saslaw (1996), Candace Brower (2000), and Steve Larson (2012) have presented more detailed accounts of the force structures in melodic and harmonic progression such as tonal tension, stability and instability, and contraction and expansion (see also Gur 2008). Eitan and Granot

(2006; Granot and Eitan 2011) further presented experimental evidence for consistent connections between complex musical features (e.g., musical tension) and imagined motion. Still, many issues, such as how the link between sound and gesture works in different listening contexts and how the particular metaphors have developed historically, need addressing before we can arrive at a more systematic account of how metaphors allow us to cognitively organize sound qualities.

We use metaphors all the time in order to understand auditory experience and to communicate auditory experiences to others using language, graphical representations, or bodily gestures. In fact, we cannot not use them. But we are not, in general, consciously aware of how we use them. Accordingly, the tool status of metaphors is largely unresolved. What this means is that metaphors are there for us only as background elements that we may potentially bring closer to the foreground if we learn to understand better how these elements work. One of this book's main aims is to foster such awareness in order to justify the metaphor in music and sound analyses and in other forms of communication about sound. I agree with much of the recent cognitive linguistic school of thought which holds that language (including body language and graphical visualizations) is the gateway to understanding human reasoning. Obviously, language itself does not lead us to a complete outline of human cognition, but through analyses of language use we can come to know more about the structure of its source in human consciousness.

"Get Together"

In order to more fully outline the practical relevance of a cognitive approach to sound quality, I present here an analytical example that takes as its point of departure a cognitive approach to the analysis of sound in music. The example is the opening of Madonna's "Get Together" from the album *Confessions on a Dance Floor* (2005), produced by Stuart Price. Reviews of the album often are centered on the texture of the synthesizer sound. For instance, in a review in *New York* magazine the sound of the album is characterized as "tactile" and "lush." It is, the reviewer writes, "one long, shimmering synthesizer riff. The riff gets faster. It gets slower. It crests. It falls. It stutters. It flows" (B. Williams 2005, n.p.). Naturally, brief as most music reviews are, this characterization is very general in that it tries to condense the experience of the entire album (57 minutes of music) into a limited number of perceptual essences. The description is thus a glimpse of the reviewer's experience of the music—compressed in time.

One may find that the reviewer's description appears subjective and unsubstantiated by any reference to how, more specifically, the description emerges when listening to concrete passages in the music. Yet it is easy to point to cognitive metaphors that structure the descriptions in the review excerpt—most explicitly, metaphors derived from the domain of tactility but also from the spatial domain, such as *movement* and *pace*.

The opening passage of the song, which I consider in the following paragraphs, involves spatial metaphors and action metaphors, and I illustrate some of the ways in which these metaphors are activated in the listening experience.

"Get Together" opens with the sounds of two school bells[3]—the first in a higher pitch than the second—that gradually fade away. The bells are followed by a synthesizer pad repeating a four-bar chord progression E minor–F major–G major–A minor and a second synthesizer playing a single note, A, on top of the chords.

On top of the synthesizer pads, Madonna is singing the phrase "It's all an illusion, there's too much confusion." The vocal part has a peculiar status in the mix. The phrase is heard both forward and backward; it appears in a close position moving away and in a distant position moving closer. We may think of the vocal sound as hovering over the synthesizer sounds, an experience fostered by the lack of spatial grounding, the phasing effect, and the backward-and forward-motion of the phrase. For similar reasons, the vocal sound appears light—almost weightless—and, considering the lyrics in relation to the sound, the experience of the voice as disembodied and ephemeral emerges.

The synthesizers are dark-sounding primarily as a consequence of the low-pass filtering. One might also call them slightly muddy or blurred because one cannot clearly distinguish the sounds from each other. Over the course of the next 35 seconds an upward equalizer (EQ) sweep gradually brightens and opens up the synthesizer sounds. About 20 seconds into the track the synthesizer starts to sound more grainy or rough. The perceived graininess or roughness, mapped from the surface structure of a physical object, comes to our hearing more clearly as the sounds become brighter. The connection between the increasing brightness and roughness of the sound is also found in the metaphor's source domain: a visual object. Objects hidden in the dark are usually hard to distinguish, and we can also experience a limited sum of their qualities—and so, when the object becomes brighter, a number of textural qualities emerge more clearly for the perceiver.

There is also a perceived motion in the EQ sweep that is worth considering. The motion and the gradual opening of the sound may be understood

in one of two ways. In many analyses, an upward sweep in the beginning of dance tunes represents the acoustic change as you enter from the corridor at a dance club to finally find yourself on the dance floor. Viewed from this perspective, the listening subject moves relative to a static acoustic environment. The experience arises if the listener perceives in the sound an auditory pattern that matches a similar pattern stored in memory (see Margolis [1987] for a theory of pattern matching). Still, this pattern differs from actual movement in at least one significant way: The motion trajectory is propelled by the sound itself; there is an inherent motion-force that takes the listener down a specified path. We instead perceive that the sound gradually opens up before us— making itself available to perception in such a way that we can audition more of its inherent qualities. Viewed from this perspective, the sound alters from a *closed* to a relatively *open* state.

At 30 seconds the forward-moving motion is temporarily replaced by a circular movement caused by the continuous repetition of the synthesizer and vocal ostinato—"-usion, -usion . . ."—followed by a stutter effect. When the kick drum comes in at 40 seconds, the density of the sound in the overall sound container (see my definition of this term in chapter 2) increases. The kick drum sounds punchy, a quality connected to the distinct attack and boost in the area of 80 Hz, which resonates in the listener's chest region. More interesting is the very prominent effect triggered by side chain compression.[4] Every time the kick is heard, it fills out the virtual space of the recording (the overall sound container) and consequently ducks the other sounds in the mix, and when the kick disappears the sounds come back up again. In this sense, the kick drum is big, but it also possesses a relative strength that gives it priority in the mix whenever it appears. The strength is directly connected to its heaviness. It adds substantial weight to the center of the mix and thus functions as a firm anchor point that keeps the mix in balance.

Sounds function as dynamic entities that act and react to each other within the mix. The specific qualities of each sound—the strength of the kick, the lightness of the vocals in the intro, the synthesizer pad's trajectory from darkness to lightness, and its upward movement—all serve a specific function within the mix that contributes to the experience of the track as a whole. The main sound quality features of the first part of "Get Together" can be summarized with the following metaphorical descriptions:

- the shift from a dark and smooth to a bright and more rough or grainier synthesizer sound
- upward motion (mainly caused by the EQ sweep in the synthesizers)

- the spatial tension—contraction and expansion—that takes place when the kick hits in (primarily caused by the side-chain compression)
- the lightness of the vocal and the way it hovers over the synthesizer sounds
- the horizontal spatial motion of the listener relative to the sound

None of the experiential patterns mentioned here is literally in the sound, nor can we replace these metaphorical descriptions with accounts of the sound's physical attributes in any meaningful way; the fact that I am naturally inclined to use metaphors to explain other metaphors underlines this central point.

What Is Sound Quality?

Before I expand on the role of metaphors in descriptions of sound quality, it is worthwhile providing a definition of *sound quality* as it is used in this book. Leaving, for now, the term *sound*, which is discussed in chapter 2, I will clarify what I mean by the *quality of sound*. It typically is defined in two ways: First, *sound quality* may refer to the implied grade of excellence we attach to sound. A general feature of this understanding of quality is that we use it to assess whether something is good or bad. For instance, if someone argues that CDs have sound quality superior to that of vinyl records, he or she is implying that CDs' degree or grade of sound excellence is better than vinyl's. This comparison only makes sense, however, if this grading is made according to an ideal sound quality standard. If CDs are considered to render better quality audio than vinyl records it must be because CD quality is closer to the ideal than the quality of vinyl records. Most commercial discourses of sound quality revolve around this logic. The ideal sound quality varies a lot, however, in sync with technological and cultural changes. Consider, for instance, the development of new digital audio formats such as MP3 and AAC. YouTube, iTunes, Spotify, and DAB radios feed us daily with data-compressed audio, and some people rarely experience CD-quality (i.e., *technical* quality) audio. This tendency, we may speculate, could lead to a new generation of listeners with other sound quality preferences. Research by the Stanford University professor Jonathan Berger (see Dougherty 2009) adds fuel to this thesis. Berger tested first-year university students' preferences for MP3s annually for ten years. He reports that each year more and more students come to prefer MP3s to CD-quality audio. These findings indicate that listeners gradually become accustomed to data-compressed formats and change their listening preferences accordingly. The point is that while technical improvements strive toward increased sound quality in a technical sense (e.g., higher resolution and greater bit rate),

listeners' expectations do not necessarily follow the same path. As a result, "improved" *technical* digital sound quality may in some cases lead to a decrease in the perceptual worth of the sound.

Second, *sound quality* may also refer to the distinctive features of sound. These features may have a positive or a negative value, but our main objective is to assess the characteristics of these distinctive features. This definition, however, raises new questions about the nature of these distinctive features, where to look for them, and how to articulate them. Several audio engineering books provide instructions for the evaluation of sound quality that often focus on the physical dimension of sound (what we can measure with technical instruments) and often focus on a limited set of characteristics. For instance, in the chapter on evaluation of sound quality in his book *The Art of Recording* (1992), William Moylan reduces sound quality to four components: dynamic contour, spectral content, spectral envelope, and pitch definition. The characteristics of each of these components may then be plotted on a graph. Like sound evaluation firms such as Delta Lab, the objective for Moylan is to establish a shared vocabulary to communicate meaningful information about sound by teaching listeners to evaluate the physical dimension of sound. Meaningfulness, for Moylan, thus emerges from the ability of terms to describe specific physical characteristics of sound. In an ideal objective world, the physical dimension of sound will map directly onto how we perceive it. This—unfortunately, some might say—is not the case. Although we may train our ears to listen for certain physical parameters, and maybe come close to the data that a computer-generated analysis may provide us with, such training still does not solve two basic problems: (1) that certain characteristics of sound are only experienced and cannot be measured and (2) that listeners experience and cognitively process recorded sound in the context of a specific piece of music and in the context of a wider cultural discourse of sound.

The definition of sound quality that I adopt in this book derives from the second definition: the distinctive features of sound. I do, however, incline toward a more listener-based definition that accounts for variations in the listening context. Obviously, the standard of 1920s music recordings would not satisfy the sound preferences of most listeners today. This highlights the fact that a change to the worth of the sound may not be measurable in the actual sound signal. More important for my take on sound quality, the distinctive features of sound are also tied to the historical and cultural context. The judgment of the sound quality of a specific track is based on several factors over and above the measurable parameters of the physical sound signal. For instance, knowledge about technologies used in the recording process or the playback equipment may greatly influence perceptions of sound quality. I thus

seek a more inclusive investigation of sound quality that does not limit itself to a finite set of attributes but, rather, provides the cognitive, cultural, and historical background for the way we reason and think about sound quality.

Taking these contextual aspects into account, there is a complex relation between sound quality descriptions, the cognitive metaphors at work at the level of thought, and the physical sound signal. Descriptions of sound quality are shaped by subjective preferences, cultural background, and so on, but that does not make sound descriptors arbitrary. Insofar as many embodied experiences (such as spatial experiences) are largely shared—despite personal or cultural differences—there is also a shared cognitive system on which we build common descriptions.

Idiosyncratic Metaphors Versus Universal Metaphors

When I started researching metaphors in the language concerning sound in about 2010, I interviewed a handful of Danish sound engineers about their work and how they characterized a good sounding recording. Although I found these talks inspirational and joyful, I quickly found that this approach would not allow me to systematize such metaphors. There were two main reasons why this approach was abandoned: First, I found, much to my surprise, that it was difficult to get sound engineers to address the characteristics of sound quality itself. For instance, when asked about how they envision the sound of a particular song, they often would refer to the technology used to make the sound, and only occasionally (or when specifically asked to do it) would they attempt to describe the qualities of the sound without referring to the source or the mediating technology.[5] Second, it would be necessary to perform several hundred, perhaps thousands, of interviews in order to deduce a systematic metaphorical framework for characterizing sounds. Given that I had only a few interviews at my disposal, the idiosyncratic language of individual sound engineers prevented intersubjective regularities in the language from emerging. One of my informants consistently opposed sharp (*skarp*) sound to dark (*mørk*) sound, and these two words were by far the most common sound descriptors in the interview. The fact that *sharp* and *dark* do not form an opposition in any logical sense—they do not even belong to the same sense domain—did not seem to bother him. And why should it? His idiosyncratic way of expressing features of sound quality reflected values, ideas, and visions about what a good mix was for him. Perhaps the sound engineer was (unwittingly) activating three sensory domains—sharp object

(tactile domain), sharp light (visual domain), and sharp sound (auditory domain)—while only traversing the last two, in which case the visual domain serves as the source domain in which sharp light (a bright and piercing light) forms an opposition to dark light. Yet, and this is the reason why I mention this example, it underlines the need to examine the role of sound quality terminology in a wider context. If sound quality descriptors based on metaphors are to have any broader value in academic analysis of recorded music, it is imperative that one learns to distinguish idiosyncratic terminology (deduced from individual cases) from intersubjective (or more universal) terminology (deduced from a larger data set) to avoid the danger that the vagueness of sound quality terms transforms discourses about sound quality into semantic emptiness—discourses full of concepts with meaningless content.

For this reason, I decided to compile a large linguistic corpus (more than 50 million words contained in digitized texts) with different forms of literature about sound (e.g., sound engineering magazines, music reviews, hi-fi magazines, and various books, papers, and magazines about acoustics, recordings, and music). This corpus has been a major source for much of my later work (see Walther-Hansen 2016, 2017, 2019; Walther-Hansen and Grimshaw 2016), and it has also informed much of the thinking in this book. Although computer-generated analysis of written text (corpus linguistics) is not the answer to all prayers, it is useful in identifying typical patterns in language about sound across texts and contexts. Searching for the most typical sensory adjectives that collocate with sound, for instance, provides the following list of metaphorical concepts characterizing sound quality: big, natural, little, pure, high, warm, full, open, clean, rich, smooth, detailed, clear, fresh, raw, thick, thin, punchy, huge, short, flat, dry, aggressive, powerful, deep, wide, tight, heavy, bright, dense, sweet, rough, massive, solid, low, harsh, hard, small, sharp, flexible, crunchy, crisp, fat, delicate, weighty, transparent, subtle, soft, robust, and quiet.

Some of the modalities that typically serve as donors for sensory adjectives are dimensions (e.g., big, wide, high), force (powerful, aggressive, punchy), physical objects (soft, dry, robust, heavy), temperature (warm), and vision (bright, transparent). This list provides some insight into the typical transfer of concepts from one sensory domain to the domain of sound; it is difficult, however, to pair the descriptors to the sound being described because there is no sound accompanying the text. Accordingly, it is merely possible to deduce some general features about how sound qualities—whatever the specific sound quality might be—are conceptualized in language, and these language patterns may be used as evidence for the structure of the cognitive processes governing the use of specific linguistic concepts.

Exploring Metaphors of Sound Quality in Context

In order to further illustrate my approach to the study of perceived sound quality, I consider two descriptions of sound quality found in issues of *Billboard*. The first quotation is taken from a review of the English singer Petula Clark's album *Now* (1972): "This is not the Pet Clark of heavily-textured, complex productions as she was associated with in her heyday. But her distinctive big, warm sound remains pleasurable as ever" (*Billboard* 1973, p. 55). The second is from an interview with the producer Garry Tallent about his vintage sound studio: "The stuff we are after is natural. A lot of old tubes and stuff gives it that natural warm sound" (Bessman 1998, p. 40). Looking for qualifiers to describe sound quality, we immediately identify the adjectives *big, natural*, and *warm*. These descriptors are quite common in descriptions of sound quality, but in order to understand how they make sense in describing the experience in this particular context we must explore their function as metaphors. For now, let us focus only on the term *warm*.

Warm is used as a metaphor in several domains. Its use to describe feelings can be traced to the fifteenth century (Harper 2015, n.p.), and *warm* is a common qualifier to describe a welcoming atmosphere. Warmth is generally a desirable quality. In the description of sound, this positive quality is retained (see the entry "Warm/cold" in chapter 4). For instance, a number of software plugins for music productions are sold for the sole purpose of adding warmth to the mix. But how are we to make sense of warmth in sound, besides its seemingly positive qualities? A proposal for doing so will emerge in the discussions in this book. Here, I briefly outline a few of the main features that govern how we make sense of *warm* as a quality of sound.

The literal meaning of *warmth* is a certain temperature range. We can measure the temperature with a thermometer to determine whether something is warm, and we can feel the sensation of warmth if we touch a warm object or when the air around us feels warm. When we say that music has a warm sound we clearly do not refer to the temperature of the sound waves or the sound source, for instance, a drum set heated to a certain temperature. The warmth of the sound is real, however, in the sense that listeners understand and reason about sound quality in terms of the concept of warmth. The notion of *warmth* as a qualifier for sound makes sense because the sound produces a sensation that the listener cognitively processes and structures via the notion of temperature. This happens because there is a link at the level of thought between the quality *warm* as applied to physical objects and a warm sound.

The question, then, is not *if the sound is* warm, but *how it is* warm. What is the nature of the cognitive processes that make me experience it and describe

it in this way? To grasp the metaphoric expression involves mapping the properties of the physical understanding (warm as a temperature) onto the more abstract domain of sound quality. I explain these principles thoroughly in the following chapters, and I present mappings for a number of sound quality metaphors in the encyclopedia found in chapter 4. In the following section I exemplify how the use of the metaphor of warmth reflects changes in the discourses of sound, discourses that, by and large, are tied to the development of audio technology.

Reviewing the two quotations from *Billboard*, we get a glimpse of such a change. In the one from 1973, warmth qualifies the sound of Petula Clark's voice. It is expressed as a quality her voice possesses rather than a quality the recording itself happened to produce. In the 1998 quotation, *warmth* refers to a quality of the technology that was used to record the sound. Warmth is something that technology, in this case tube amplifiers, adds to the sound in the recording process rather than a quality of the actual prerecorded sound source. The distinct foci in these two quotations could be coincidental. As we shall see, however, they form part of a much more general tendency in the discourse of sound that began to appear in the 1980s with the introduction and dissemination of digital audio technology. Before the digital era in the music industry, most talk of musical sound was related to the sound produced by singers or instruments. One could, for instance, talk about the warmth of the singer's voice or the warm sound of the trumpet. A search for phrases that includes the word *warm* in a corpus of music reviews reveals a shift in the use of this in about 1990. At that time there was significantly more talk about the warmth of different recording and playback technologies than about the warmth of human sound sources. *Warmth* describes the sound quality of, for instance, vinyl records, tube amplifiers, analog synthesizers, and tape machines.

This tendency does not, however, imply that audio technologies are experienced as being warmer in the age of digital audio. In fact, the shift in discourse points to quite the contrary tendency in that it was fostered by a concern about the quality of digital audio. Already in 1988 Andrew Goodwin noticed this shift in discourse in his essay "Sample and Hold: Pop Music in the Age of Digital Reproduction." Analog synthesizers, which were considered inhuman and cold during the 1970s, were reappropriated during the 1980s and 1990s mainly because they were considered more authentic than their digital counterparts. We find a similar tendency in the debate about CDs versus LPs during the 1980s. Especially among audiophiles, the vinyl disc was increasingly recognized as being more real than its digital counterpart. Accordingly, the gradual shift from analog to digital audio fostered a longing for the sound

of old analog technologies. This longing arose from the struggle over who should define and own the notion of *the good sound*. Audiophiles claimed that analog equipment produced a more human and warm sound. The industry, on the other hand, claimed that digital audio surpassed the sound quality of analog audio. Between these two positions, new discourses of sound quality emerged. The alleged perfection of the digital came to mean a reduction in the human and warm element in music for many listeners. Something was lost in the process, and this loss was something that many music producers made a great effort to restore, either by using real analog equipment (e.g., tube amplifiers) or by using digital emulations of these technologies. As a result, the digital era saw an increased focus on the warmth of the sound. This points to the changing significance of metaphorical descriptions in the context of new technologies and, the gradual shift from analog to digital audio technologies makes a particularly interesting case.

Digital Audio: Toward (Im)perfect Sound Quality

Digital audio is often thought of as simply a particular way to store and play back audio, but the introduction of consumer digital audio in the 1980s came to have a profound effect on the way sound quality was articulated. Timothy Taylor (2001) went as far as to call the introduction of digital audio "the most fundamental change in the history of Western music" (p. 3) since the introduction of musical notation in the ninth century. This statement may hold some truth when seen from the composition and production side of things. Digital audio allowed for strikingly new ways to create music, facilitated by the ability to record and compose an entire piece of music on a computer at home. One important outcome of this development, and what makes these new practices noteworthy in this context, was a renewed interest in sound as the main musical component. Often the particular sound quality formed the basis for songwriting, as composers would often design a particular sound and then develop the composition from there. Such practices, of course, also existed in the pre-digital era, but on a much smaller scale than after the introduction of digital audio. For music producers and sound engineers, digital audio also had a profound effect on the production process. One of the more significant changes was that the affordability of digital hardware and software allowed laypeople with an interest in music to record music with a somewhat professional sound quality at home. Among the major benefits was the ability to bypass the time constraints and expense of commercial studios and to obtain full control of every step in the process.

This broadened access to music production technologies is often termed the *democratization of music production* (Goodwin 2006; Burgess 2013), usually with reference to the accessibility of music production software. This increased accessibility, is above, all physical (e.g., the opportunity to get your hands on music production technology) rather than cognitive (e.g., the ability to understand and make sense of the technology). The rather demanding tasks that home music producers needed to master in order to make a good-sounding recording are still present in the digital domain, and for this reason the alleged democratization never really appeared. Accordingly, sound production is still not in the hands (and minds) of everyone. Designed primarily with analog technologies in mind, most audio editing software assumes some preexisting knowledge about how to record and mix in the analog era. In the first digital recording systems the analog became a key metaphor for providing a smooth transition between these domains. Many concepts and practices, such as the Play and Record buttons and the Cut, Rearrange, and Paste procedures, were largely transferred from the analog to the digital. These key concepts from analog tape editing came to serve as the basic tools in most audio editors. Moreover, most interfaces designed to control music software closely resemble a compact version of analog mixing desks. The point is that the analog remains a strong metaphor in the music industry (too strong a metaphor, some might claim). Although most sound editing can be done much more quickly in the digital domain, the fundamental logic accompanying music production did not change radically. The so-called digital revolution in the music industry offered every possibility to rethink the main mode of thinking and interacting with sound—but it did not. The role of the digital was, in a certain sense, to represent the analog. Sound waves were now represented in ones and zeroes on hard discs instead of being stored as electric current on magnetic tape. This change led in turn to greater flexibility in the production process and cheaper equipment, and by the mid-1990s almost any hardware effect was to some extent replicated in the digital domain, but it did not lead to a complete break with past practices.

From the point of view of consumers, digital audio held out the prospect of unsurpassed sound quality. Introduced to the public in 1982, the compact disc became the main consumer symbol of the digital era. The disc was hailed for its superior sound quality compared to vinyl LPs and cassette tapes. It could contain more minutes of music, it had less background noise, and, it was claimed, it did not wear out. Philips and Sony marketed the disc with the slogan "pure, perfect sound forever," stressing both the CD's superior sound quality and its durability. Looking back at this slogan now makes one wonder about the need to continually develop a number of the CD's technical features,

such as increasing oversampling and error correction. The CD was, in fact, not perfect—at least, not in a technical sense—but the makers' claim that it superseded past audio technologies points to the key discourse of sound quality that accompanied the introduction of the CD. Focusing on purity and perfection as the key qualities of CDs, they averred that they had solved issues related to background noise such as vinyl rumble and tape hiss. The CD was thus "perfect" exactly because it got rid of all the undesirable sonic artifacts of analog media, leaving only the "pure" sound. This essentially meant a noise-free rendering of sound.

Despite the industry's persistent assertions that CDs rendered perfect sound, critiques stressed that vinyl records sounded more musical and life-like. Some audiophiles even claimed, and many still do, that CDs sounded "too perfect" or "sterile" in comparison to the vinyl disc, and a number of virtual studio technology (VST) plugins for music production were invented in order to bring some of the analog feel back into the sound.[6] Bad Buss Mojo (a plugin from Stillwell Audio) is an example of a software plugin that was marketed with the sole purpose of undoing the perfection of digital audio. In a special issue of *Computer Music*, moreover, a "perfect"-sounding track is listed as one of the ten signs of an amateur mix:

> Many producers feel that computers have made music too perfect, and we think they have a point. . . . The slick production sheen that's imparted by today's music technology can often make tracks sound samey and uninspiring. . . . Your music might benefit if you make things a bit more organic, a bit earthier and a bit more raw. . . . Sometimes you want to allow or even flaunt some slight imperfection. (Robinson 2012, p. 10)

As this quotation reveals, the very same words that the industry used to brand digital audio in the 1980s were later used to describe what was wrong with it—its perfection. *Perfect* simply came to contrast with other sonic qualities, such as organic, human, or raw, that many listeners look for and worship in musical sound.

Where does this account of the relation between metaphors and technological change lead us? First, it shows that the meaning of specific linguistic metaphors is not stable. Meaning is closely tied to technological developments and the wider context. In order to understand the discourse of sound, then, we do not need to know the meaning of specific linguistic metaphors, but we should know the function of the larger conceptual system in the historical and cultural context. Second, and this in part modifies the first point, metaphors provide continuity across technological changes. As we have just seen, a closer

examination of our conceptual system and its inherently metaphorical properties helps us realize the logic in the analog/digital debate. Digital technologies are, for most people, at least, inherently abstract, but by using the analog as a metaphor in the design of digital interfaces, we can better relate these new technologies to the past technologies that users are already familiar with (i.e., the metaphor concretizes the abstraction of the digital).

The following chapters build on the idea that listening to music or interacting with recording technology is achieved through a structure of related cognitive metaphors. The intention is to guide the listener through the steps necessary to evaluate the relation between sonic experience and language.

The Plan of the Book

Part I is divided into three chapters. I discuss theoretical and methodological approaches to the study of sound quality in recordings. The aim is to guide the reader through the cognitive processes, cultural discourses, and technological developments that influence our experience of sound. In order to do this, I combine more philosophical theories of listening with cognitive linguistic theory and treat descriptions of sound quality as ways to obtain knowledge about the embodied cognitive system by which we think, act, and listen to music.

Chapter 1, "Discourses of Recorded Sound: Technologies, Production, Listening, and Conceptualization," looks at descriptions of sound across texts and across historical contexts. The chapter accounts for change and stability in the way sound quality is processed in relation to discourses of sound. It shows how listeners, the industry, and other communities create social identities and build specific listening preferences via the discourse of sound quality.

Chapter 2, "The Ontology of Recorded Sound," begins with a discussion of the role of the metaphor in the formation of sound's ontology by situating metaphorical descriptions of sound within a discussion of existing definitions of sound found in various musicological and philosophical works. The chapter describes how different ontological metaphors govern the way we make sense of sound in the act of listening and the way they are used as cognitive tools for doing certain things with sound in music production. It is argued that we conceive of the general being of sound by means of metaphors and that music listening and music production involve attending to sounds at different ontological levels simultaneously. In order to make sense of the way listeners conceptualize sound quality it is, therefore, necessary to account for how sound *exists* for listeners in different ways.

Chapter 3, "Sound Quality: Reasoning, Action, and Language," takes a closer look at sonic concepts and the relevant major strands of research in the cognitive sciences. Having argued for how we make sense of sounds at the ontological level in Chapter 2, in this chapter I explore how the cognitive processing of sound is a multimodal task that extends into the world through language, technology, and actions. Although the main source of information in this study consists of cognitive metaphors reflected in written accounts, the chapter also outlines nonlinguistic realizations of sound quality such as visual metaphors (e.g., graphical user interfaces) and enacted metaphors (e.g., bodily actions).

Part II which is in encyclopedia format, assesses metaphors that are often used to describe sound quality. Each entry explains the embodied cognitive patterns that connect sound descriptors with the listening experience. Furthermore, it describes how the language and meaning of sound terminology have changed through history and how these changes relate to technological developments. Chapter 4, "Conceptualizing Sound Quality: An Encyclopedia of Selected Sound Terminology," is built around 30 metaphorical expressions presented in 15 pairs of opposing terms. Each entry discusses related terms, and each term is examined in relation to its metaphorical use and the discourses underlying sound and music communities, as described in Part I.

Following the steps outlined here should allow the reader to make informed decisions about which words to use in communicating sound quality, to more fully comprehend what is being communicated, or to reflect on experiences of recorded sound. I should emphasize that most of the entries in the encyclopedia require that the reader be familiar with the theoretical framework presented in Part I. Knowledge of cognition and philosophies of sound and listening are inseparable from an understanding of the actual sound under examination. I therefore find that these skills are essential in order to perform analyses of recorded sound, and they should be highly valued by music producers, academics, and anyone with an interest in recorded music.

PART I

FOUNDATIONS AND THEORY

1

Discourses of Recorded Sound

Technologies, Production, Listening,
and Conceptualization

In literature about cognitive linguistics, our cognitive system is usually described as a relatively stable organization of cognitive metaphors that allow us to make sense of the outer world and each other over time. Still, cognitive metaphors evolve in relation to the social context in which they are activated, for instance, in the wake of new audio-technological inventions, music genres, and so on. In this chapter, I begin to discuss how the cognitive system that processes auditory experience changes over time. I do so by situating the cognitive processing of sound quality in the contexts in which they arise and develop. The aim is to show how language both reflects and constructs meaning and, accordingly, creates discourses. Also, I discuss how discourses of sound have themselves both informed technological developments and inspired new forms of musical expression and listening modes, leading to new aesthetic ideals of sound. Two overall tendencies are explored in this chapter: First, I examine general features of recorded sound that have changed with the emergence of new recording and playback technologies such as electrical recording, multitrack recording, and digital audio. Second, I show how the way listeners attend to recorded sound has changed and how these changing modes are related to the wider discourse of recorded sound. The latter is explored in more detail in chapter 2.

Developments in recording and playback technologies as well as various improvements in recording craftsmanship, more creative and artistic approaches to record production, and so on have changed the status of sound within the discourse of sound. I argue that this shift in status implies that *sound quality* has become an increasingly difficult term to work with. There are numerous reasons for these difficulties, but of main importance is a move toward *aesthetic idealism* (a focus on the characteristics of the sound itself as it emerges in perception) as opposed to the *aesthetic realism* that was prevalent in the first half of the twentieth century. Today, and to some extent since the 1950s (see Zak 2001, 2012), the aesthetic judgment of sound quality is

Making Sense of Recordings. Mads Walther-Hansen, Oxford University Press (2020). © Oxford University Press.
DOI: 10.1093/oso/9780197533901.001.0001.

less concerned with reality than it is with ideality, and this makes arguments that rely on the tools of psychoacoustics less useful—or at least problematic. In order to further outline the role of metaphors in experience and reasoning about sound, I argue that sound quality is socially constructed and that certain listening preferences are cultivated within specific discourses.

Sound Terminology: A Necessary Evil?

> Books and academic papers can easily reproduce visual images but not sounds. If the sound themselves cannot be reproduced, then an even greater premium is placed upon the language used to describe and represent auditory phenomena.
>
> **T. Pinch and K. Bijsterveld, New Technologies in Music**

The conceptualization of sound in language both shapes and is shaped by our thinking, and sound terminology emerges from a necessity to describe auditory experience. The following is a nonmusical example from before the invention of recorded sound. In the early nineteenth century in the British journal *Medico-Chirurgical Review*, Thomas B. Cuming (1828) described the cough of patients suffering from pneumonia in this way:

> It is difficult by description to convey an accurate idea of the sound to which I allude. I would call it a dry sound, in contradiction to the other, which may be termed humid. It seems to be owing to a straitening of the air-passages, occasioned by the inflammatory turgescence of the membrane in which they are lined. When secretion takes place, this turgescence is in a great degree removed, and then the sound, from being dry, becomes moist and wheezing. (p. 522)

In the nineteenth century, descriptions of sound quality often were used in articles about medical science to communicate auditory symptoms of different diseases. For many diseases the correct diagnosis was bound up with the doctor's ability to recognize the sound quality of, for instance, a patient's breath or cough. As can be seen from the quotation by Cuming, describing the characteristics of the sound was seen as necessary in order to communicate the connection between sound and disease. He could not refer to an established medical terminology for auditory symptoms of pneumonia, and he therefore pointed out that the terms he used to describe the sound were subjective ("I would call it"). He then clarified what he meant by pairing the metaphorical opposites—the dryness of the sick patient's cough with the

humidity of the healthy patient's cough. The metaphors—attributes from the domain "air" mapped to sound—serve an important function in this account as the means by which the complexity of the sound can be articulated more precisely. Still, the author seemed to have little confidence that readers would readily understand what he meant.

What is at stake is the common view of auditory experience as more subjective than visual experience. People typically are less confident that other people heard the same thing than they are that others saw the same thing. Cuming articulated sound quality of necessity—a necessity fostered (in this case) by a wish to improve medical techniques, to cure more patients, and so on. Cuming relied on (what he saw as) his own subjective experience to conceptualize the sound in language. The words *reflected* his experience. At the same time, he provided a definition of the concepts for future doctors to use and in doing so he shaped, or constructed, a certain way to audialize (i.e., form a mental representation of sound) variations in the sound of the cough. The linguistic concepts highlighted a specific form of sensory awareness and aided in shaping his and other perceivers' cognitive capacities, serving as the basis for future auditory experiences. In this way, Cuming's description can be seen as a contribution to an emerging recognition of auditory attributes in his field where "knowing is seeing" and hearing is generally ranked subordinate to vision.

Listening for Sound Quality

The need to articulate sound quality has also been driven by a striving for improvement in the music industry. The history of recorded sound is, by and large, a history of audio-technological innovations that, the industry claims, improve sound quality, but it is also a history of how these innovations directly or indirectly influenced the way music consumers, musicians, and music recordists make sense of recorded sound. One could choose to see innovations such as electrical recording, multitrack recording, and digitization of recording and playback media as gradual and necessary progressions bringing the sound quality of recordings closer to perfection. But even the most biased historian would probably agree that technological progress does not work like that. In fact, many technological changes have not concerned sound quality per se; durability of the media and playback equipment, accessibility of music, visual design, ease of use, and other factors all have played major roles in the development of new technology, and some of these improvements have been at the expense of the sound itself.

One could point to the dissemination of the cassette tape in the late 1970s and the rise of the MP3 format in the 1990s as key examples of this phenomenon; these formats gained popularity because, among other things, they allowed for easy sharing of and access to music. But some would also argue that the so-called improvements listed above are actually technologies that fostered acceptance of the deterioration in quality of recorded sound. The point is that technological advances are constantly negotiated. Every time the audio industry hails allegedly improved features of new technologies, countermovements emerge arguing that the sound quality of the old technologies exceeded that of the new ones. These countermovements play a significant role in bringing sound quality discourses to the fore. Without resistance—differences in taste, values, and so on—there would be little need to discuss how we make sense of sound quality, and communication about sound quality probably would be reduced to a question of "better or worse." It is the disagreement that challenges that binary pair. Each position needs arguments, which heighten our understanding of the matter. Such debates also inevitably increase complexity and put pressure on language. We all, once in a while, use less-than-satisfactory explanations such as "I like this music more because I think it sounds better." But when our views are challenged, we are forced to come up with more elaborate justifications for the worth of our preferences.

Ask a friend who listens to vinyl to describe why he or she prefers the sound of vinyl to digital sound. He or she will most likely develop an argument including one or more sound quality metaphors. Why? Because vinyl lovers need the metaphor. Following the commercial release of the CD (discussed briefly in the introduction) in 1982, the industry has presented different forms of evidence for the claim that CDs sound perfect, evidence based mainly on acoustic measurement and the durability of the medium. In the wake of these claims a more elaborate vocabulary emerged among vinyl lovers to argue that the vinyl-listening experience was still superior despite the "hard facts."

The vinyl-versus-CD debate and the related analog-versus-digital debate are ongoing. In a thread named "Vinyl vs. CD?" (2011) on the online forum *What Hi-fi?*, the administrator asks for the users' opinions on the subject:[1]

I was wondering what other people really thought about the Vinyls [*sic*] vs. CD argument: which do you prefer, and why? . . . Over the last few days I've been playing a lot of . . . vinyl. Now, to me, it sounded amazing: perfect clarity, clear separation of voices, good dynamic range, smooth, natural. Apart from the crackles and pops . . . , I'd say the natural, non-complicated, sound of vinyl is way better that [*sic*] a CD. . . . CDs gave a much more powerful, louder and "produced" sound. They were

certainly louder, also gave incredible detail but to me they just sounded too polished compared to vinyl. (user: admin)

Most users responded in line with the administrator's view. A few excerpts are presented below:

- I find that Vinyl tends to be a lot less "Produced" and has that warmer natural sound that you just don't seem to get with CDs. Vinyl also tends to be a more "touchy" medium as well. . . . there is something about handling an LP, placing it on the turntable and lowering the tonearm and then having to get up to turn the LP over. (user: Jason36)
- I'm a recent "returnee" to vinyl after 30 years, and have started buying vinyl again. . . . Fabulous, warm, full sound. (user: DandyCobalt)
- After listening to the Gyro [record player], when I listen to the CDP [CD player], it sounds recessed, like the CDP is actually acting like a resistor, strangling the life out of the music. . . . The best way I can explain the sound of the Gyro, is it's like listening to the band, or artist that you are listening to, live. Unlike the CDP, which is close but no cigar, the Vinyl is bang on. Exactly like the real voices and instruments. (user: bretty)
- I feel that vinyl has more clarity and less fuss about it. I like the sound. I could listen to it all day and not feel tired. (user: Anonymous)

The sound quality issues raised in the administrator's post and in the replies suggest that vinyl records sound natural, real, live, and uncomplicated as opposed to the CDs, which sound produced, polished, unnatural, and complicated. In order to make sense of the presented arguments it is necessary, as a point of departure, to explore the main categories "real/natural" and "unreal/unnatural" in the context of the debate. This will further allow us to discuss the effect of these metaphors on the listening experience.

The real as an ideal in record listening is tied to the belief that one ideally should hear through the medium's transformations of the sound. According to this view, "good sound" is obtained by the elimination of any effect of technology, and the goal is thus absolute transparency of the medium. This implies that when we experience an unreal or unnatural recorded sound it must be because we feel that something is lost—the medium has transformed the pre-recorded sound in a way that calls to attention the difference between (the idea of) a pre-recorded sound source and the recorded sound we are presented with. There is a complex relation, however, between the sound source in its pre-recorded form and the sound source as we experience it in recorded music. As James Lastra rightly notes, the idea of a real sound that

one medium may reproduce or transfer better than another is basically a construct. The real sound is a mental creation of a singular sensation, derived from the multiple experiences we may have of that sound. Lastra further suggests that "the primary ideological effect of sound recording might be creation of the *effect* that there is an "original" independent of its representation" (1992 p. 70, emphasis in original). Jonathan Sterne reaches a similar conclusion, writing that "Without the technology of reproduction the copies do not exist, but, then, neither would the originals" (2003, p. 219). The point is that the real is important to record listening and to sound-quality evaluation as a concept. One must assume an original sound prior to recording in order to make judgments about which medium is more natural sounding than the other. Evaluating sound in this way requires a conceptual construct that positions us in a discursive relation to the sound we hear, and it is from this "position" of listening—in the act of forming a construct of the real—that we assign qualities and meaning to the sound. In this process, new terms arrive in our language and others disappear.

Whatever words we come up with to describe the sound, whether used conventionally or innovatively, the choice of words is not random but is motivated by our need to express something and a wish to direct attention to specific qualities of the sound. This, in turn, changes the listening experience and the demand for new technologies. From the acoustician's point of view, a vinyl record may sound exactly the same today as the same vinyl on the same playback system did in the 1970s. Taking the effect of the discourses of sound quality on the listening experience into account, however, it becomes evident that listening is socially constructed. The vinyl does in fact sound different today, not least as an effect of the comparison with the CD that resulted in new listening preferences, a renewed motivation and need for describing the merits of the vinyl, a new focus on (or the emergence of) specific sound quality descriptors, and new emerging cognitive structures that govern the way we make sense of recordings.

Improving Sound

We are now in a position to assess the above observations in the context of cognitive metaphor theory, to outline how the concept of reality, or more specifically the natural, structures the cognitive processing of sound.[2] I suggest that the real/unreal and natural/unnatural dichotomies make sense and contribute to the listening experience in a specific way because they are governed by a cognitive metaphor I will call THERE IS ONE REALITY. Changes to sound

quality and listening can be viewed in relation to the concept of improvement because improvement is governed by the notion of "one reality," that is, a way to measure whether improvement actually did take place, a search for *one* future endpoint. The natural/unnatural and real/unreal metaphor pairs, then, are one way—perhaps the most logical way—to make sense of the quality of recorded sound.

The ONE REALITY metaphor in the context of recorded sound is an example of what Zinken, Hellsten, and Nerlich (2008) would call a *discourse metaphor*, that is, "a relatively stable metaphorical projection that functions as a key framing device within a particular discourse over a certain period of time" (p. 363). Cognitive metaphors often evolve with the social, cultural, and technological context in which they are activated. They change with discourses and provide a structuring system for discourses; hence the name *discourse metaphors*. The ONE REALITY metaphor became the main structural principle for sound quality near the turn of the twentieth century, and it has stayed on to become an integrated part of more persistent discourse models, as the debate about vinyl versus CD shows.

In the period following the introduction of electric recording, made possible by the improved microphone technology of the mid-1920s—an event that brought with it the first glimpses of a new sonic realism since the invention of the phonograph—another discourse metaphor began (very slowly) to creep into discourses of recorded sound. I shall call this metaphor THERE ARE MULTIPLE REALITIES. Basically, this metaphor governs the acknowledgment that recorded sound has other assets than its similarity (or dissimilarity) to pre-recorded sound (i.e., the idea of an original sound). The idea of an "actual reality" never disappeared as a structural principle for thought and language about sound, however, but new terms for sound quality started to emerge that contributed to the creation of different forms of realities (unrealities, virtual realities, and so on).

Toward the end of the 1920s, sound quality became a more important issue in the music industry, and several recording companies worked hard to improve the fidelity of recorded sound. Still, the recording companies were focused primarily on fidelity in the old sense—building on the ONE REALITY metaphor—and new inventions and recording techniques were mainly driven by the desire to improve the spatial realism of the sound. Quoting advertisements for Victor Talking Machine's "Ortophonic Victrola," introduced in 1924, Jonathan Sterne (2003) describes how artists hailed the machine for reproducing the warmth and the richness of the tone. These advertisements point to an enhanced concern with the timbral qualities of sound, yet the qualities still "belong" to the original sound; they are not

attributes of the recording or playback medium. The praise of the Ortophonic Victrola in the ads, then, was grounded primarily in its ability to "transfer" the full experience (e.g., the warmth and the richness of the original sound).

Scientific articles about sound from the 1930s started to show some concern with the distinctive timbral qualities of recorded sound and not only the improved microphone and the playback medium's ability to enhance realism. In an article published in the *Journal of the Society of Motion Picture Engineers*, R. L. Hanson discusses methods to avoid "acoustic distortion" when recording with microphone on sound picture sets. At the time of his article this was a pertinent subject; as Hanson writes: "Judgment of 'good' or 'bad' acoustics has [until now] been based on the results of direct listening rather than on those of sound recording" (1930, p. 460). What makes the matter complicated is the fact that the microphone does not function in the same way as do our ears, and distortion may occur when the microphone receives sound waves belonging to the same source but arriving from different directions. Hanson notes, "This distortion is responsible for a hollow unnatural quality" (p. 461). In Hanson's paper deviations from "the natural" are seen as bad, the vocabulary used to describe sound quality is generally derived from descriptions of the acoustics of physical spaces, and there is little recognition of an aesthetics of "unnatural sound." There are, however, early signs that the ONE REALITY metaphor is challenged by other ways to contemplate sound quality. A clearer example of this new involvement appears in a scientific paper about sound recording from the mid-1930s in which J. P. Maxfield, head of the research team at the American telecommunications company Western Electric, makes this observation:

> The effect of recording too close results in a tone quality which tends to sound "thin" and "edgy" and which lacks what musicians call the "firmness and roundness" which is so highly desired in good music. This disagreeable effect can, and frequently is, partly cured by modifying the frequency characteristic of the reproduced sound in such a manner as to decrease the intensity of the harmonics which are responsible for the timbre or quality. (1935, p. 4)

Here, Maxfield moves beyond the realism discourse to address other characteristics of the sound itself. The contrasting pairs thin/firm and edgy/round provide structure to the sonic material that is defined not by its relation to natural (not recorded) sound but through the metaphoric projection from the domain of concrete objects. Maxfield's observation, then, serves as an example of a study of recording technology that deviates from the discourse

metaphor—THERE IS ONE REALITY—found in the first half-century of the age of recorded sound.

The Emerging Concept of Reality

Before elaborating further on the emergence of new metaphors in the discourse of sound, it is worthwhile to rewind a half century to the invention of recorded sound to see how the ONE REALITY metaphor was constructed in the first place. Obviously, there were many issues with the sound quality of first-version phonographs. In the years following the phonograph's invention in 1877, individual words were hardly understandable, and the cylinders wore out after playing them back just a few times. Edison's team did try to improve the sound quality (spurred by the immediate competition from Alexander Graham Bell's Volta Laboratory, which invested a great deal of energy in improving the recording and playback quality of its graphophone), but nothing indicates any great concern with the concept of realism before the twentieth century was ushered in. Of course, sound quality had long been an important theme in musical delivery, but that was something that belonged to the acoustical (actual) world—concert halls, for instance, were constructed to provide the ideal conditions for listening to music. Similar discussions of sound quality were, at the time of the phonograph's invention, not linked to the new technologies in any meaningful way.

Despite the phonograph's quite simple construction (the technology to realize a phonograph was there many years before its invention), the idea that sound, an invisible medium flowing through air, could be captured in a physical medium and played back was unthinkable for most people. Most discussions about the phonograph should thus be seen in the context of the astonishment that greeted recording and playback of sound. In a video interview Francis Jehl, one of Edison's former lab assistants, made the following report about the machine's reception:

> People flocked here in multitudes to hear a machine talk, a simple machine, they could not believe it. I well remember the day when the phonograph was presented for the French Academy of Science, and two of its most illustrious members got up and said it is impossible[;] the man that is turning the crank is a ventriloquist. It's an American hoax.[3]

At that point in history not only was listening to recordings a convention-less activity (i.e., no prior listening practices or discourses about sound aided the

listener in the process of attending to recorded sound), but listeners lacked the prerequisites to believe in what they heard; "no single standard for evaluating phonograph performances existed because there was no single role or purpose for the invention to fulfill. The phonograph appeared before a need for its function had been identified" (Thompson 1995, p. 137). Moreover, much of the work on the phonograph was focused on its mechanical functioning and durability rather than on changing (or improving) the characteristics of the sound. In 1878 Edison claimed that " 'the apparatus is practically perfected in so far as the faithful reproduction of sound is concerned.' He based his opinion not on the recognizability of an individual's voice but on the ability of a listener to understand every word" (quoted in Thompson 1995, p. 135). Recorded sound, then, was not seen as an aesthetic artifact to begin with. The important thing Edison aimed to highlight was, at least at that stage, the fact that the phonograph delivered what could be identified as *a* sound, or perhaps more precisely, that it delivered a copy or auditory representation of another sound. Although Edison listed "Reproduction of music" as one of 10 ways in which mankind would benefit from the phonograph (see Gelatt 1977, p. 29), it was primarily seen as a machine for dictation rather than something to be used in the entertainment industry. If the spoken words were understandable, no further improvements to fidelity were absolutely necessary.[4]

The status of recorded sound changed gradually toward the start of the twentieth century. In one of the earliest and most famous advertisements to promote discs from the Victor Talking Machine Company we find a picture of a dog (Nipper) looking into a gramophone horn (figure 1.1). The picture, from about 1902, is accompanied by the text "His Master's Voice," suggesting that the dog is fooled into believing that his master is actually there. A similar situation is depicted in a 1901 advertisement for Edison's invention that shows a child with an axe sitting in front a phonograph, with the text "Looking for the band" (figure 1.2).

One should not underestimate the power of Nipper and the axe-carrying child. the ads provide a concrete situation for the abstract concept "reality," in order to aid the cognitive processing of the concept. The ads are perfectly in line with recommendations from present-day cognitive researchers showing that concrete concepts are much easier to process than are abstract concepts (e.g., a concert may quickly come to mind when processing the concrete concept "piano," whereas it takes longer to imagine situations that fit the concept "realism").[5] Nipper and the child represent and make available to the viewer (and the listener) concrete situations that allow for faster and more efficient cognitive processing of the concept of realism in the context of recorded sound.

Figures 1.1 and 1.2 *Top:* An advertisement for the Victor Talking Machine Company, 1902, painted by Francis Barraud, 1898; *bottom:* an advertisement for Edison's phonograph, 1901.
Source: The Acme of Realism. Printed in *Phonogram II* 2 (5), March 1901, 187

Another famous, and much more explicit, example of the aesthetics of realism is found in Thomas Edison's Realism Tests (or Tone Tests, as they were also called), which began in 1915 (see Thompson 1995; M. Katz 2010). The Tone Tests were a marketing strategy to convince the public of the

similarities between the *real* un-recorded sound and its recorded counterpart. Blindfolded and placed in front of a singer and a phonograph, listeners were to guess whether they heard the actual voice or the recorded counterpart. The tests set out to prove that listeners could not hear the difference between the singer and the recording. Evaluating sound quality was an act of verification. The recording industry's vision was not to come up with a distinct aesthetic for the sound of recorded music but to get as close to the real thing (or the idea of the real thing) as possible. Recorded sounds were, in a sense, nothing in themselves: One did not, or could not, discuss the sound quality outside the context of reality. Real sounds were supreme—and this served as an easily applicable standard against which to measure the sound quality of recordings.

Toward Idealism

> Recording's metaphor has shifted from one of the "illusion of reality" (mimetic space) to the "reality of illusion" (a virtual world in which everything is possible).
>
> **V. Moorefield, The Producer as Composer**

In Virgil Moorefield's account of how the producer's role became central to the creative process in the music studio, technological innovation and dissemination of technology are seen as the underlying mechanisms that drove this development. This "follow-the-technology" approach is in line with other research into the effects of music technology affiliated with the field of science and technology studies (see Pinch and Bijsterveld 2004; Morton 2006). The introduction of new technology definitely influenced the rise of new ideals of sound, but the slow pace at which (what are today considered) ground-breaking inventions were publicly accepted shows that the technology itself is only part of the story that leads to a paradigm shift.

I have already discussed how new discourses of sound slowly emerged in tandem with improved recording technologies in specialized fields in the 1930s. In listening communities the ONE REALITY metaphor was omnipresent, and when the first glimpses of an amateur hi-fi movement slowly emerged in the mid-1930s the main focus was to widen the frequency spectrum and reduce distortion as much as possible in order to obtain a clearer and more faithful rendering of the music (see Morton 2006). It was not until the beginning of the 1950s that the world first got sight of a hi-fi consumer community when the American magazine *High Fidelity* published its first issue in April 1951; at this point hi-fi consumer audio was still a niche hobby for listeners

with engineering skills. Custom-built sets, however, quickly emerged that, according to a reporter for *Time*, could "reproduce music in the home with the clarity and realism of the concert hall" (*Time* 1952).

In terms of changes to recording practice, it is easy to point out groundbreaking approaches to music recording in the mid-twentieth century; choosing an optimal (historically correct) route that follows specific events, producers, artists, technologies, and so forth that will allow us to understand how new sound ideals emerged, however, is impossible. Such a story is bound to be biased. It is not my intention to pay homage to any particular events but to provide examples of events that eventually fostered a paradigm shift in the way recordings were realized. One key development concerned refinement of the tape recorder during World War II. In the hands of the French radio technician Pierre Schaeffer (1910–1995) and the American guitarist Les Paul (1915–2009), the tape recorder allowed for new ways of manipulating recorded sound and making music. For Schaeffer, who built his compositions from recordings of real-world sounds, the act of recording marked the beginning of the compositional process. Paul is often cited as the father of multitrack recording because he added a second recording head to his Ampex tape machine.

These new practices and technologies are evidence of a new involvement with recorded sound. The invention of multitrack recording, however, is also an example of how the technical possibilities afforded by new technologies came to challenge and eventually change the common discourses of recorded sound. Paul allegedly presented the principles of multitrack recording to several recording studios in about 1950, but no one seemed to care. "I was out there all by myself with no one trying to copy my ideas or follow me. It took about five years for people in the industry to figure out that it could be used for purposes other than just Les Paul and Mary Ford" (Paul cited in Cunningham 1996, p. 31). The initial rejection of the multitrack recorder fits the wider discourse of recorded sound in this period: Recording music was about *capturing* performance. Getting performances on tape, naturally, happened in one go. It also illustrates a take on the concepts of realism and fidelity that is consistent with the ONE REALITY metaphor. Reality is preexistent and it is to be captured, not created. Milner asserts that multitracking simply "destroyed the idea that recordings documented actual performances" (2009, p. 353)—a destruction that came to foster a new understanding of the concept "high fidelity"—and this, perhaps, marks one of the clearest changes to the discourse of sound quality in the mid-twentieth century.

That this discourse is prevalent not only among audio professionals but also in listening communities can be seen in Alistair Cooke's interview with Les

Paul and Mary Ford on the television show *Omnibus* in 1953. In an attempt to counter—and make fun of—public critique of his recording aesthetics and methods, Paul demonstrates a giant machine that spits out a song with several layers of guitars after he has recorded only one guitar track onto the machine. Cooke follows up with a direct address to the critics:

> You see, ladies and gentleman, this is the final demolition of this popular and ig-
> norant rumor that the basis of Les Paul and Mary Ford's music is electronics. They
> make music the way people have made music since the world began. First of all,
> they are musicians. They have an accurate ear for harmony. They work very hard.
> They have a lot of patience and they take advantage of the trick which, granted,
> electronics make possible that you can record one part of a song and then you can
> play it back to yourself, and then you can accompany that part and keep on re-
> cording. That, I think, is the basis. (n.p.)

In a setting for discourse in which layering sound in the process of re-cording was broadly recognized as cheating, it is easy to see the reluctance to accept multitrack recording. Still, a number of the most daring major studios started to experiment with three-track recorders in the early 1950s, and slowly the reliance on "the natural" as the primary referent came to an end. Albin Zak (2012) notes that recordists "responded by crafting a language of record production—one at a time—whose rhetoric relied not on fidelity but on situating a record in a universe of other records" (p. 43). This tendency eventually paved the way for a broader change in discourse in which recorded sound started to be conceptualized as a product of the medium in which it resides rather than as a product of the sound source from which it was recorded. As early examples of how these discourses were reflected in recording practice I may, for instance, point to the tape echo effect that producer Sam Philips added to Elvis Presley's voice in Sun Studio recordings from about 1953 or Tom Dowd's recordings on one of the first eight-track recorders with groups such as the Drifters and the Coasters in about 1960. (The eight-track recorder, known as the Octopus, was invented in 1955 by Ampex but was not sold in any great number—Abbey Road Studios, for instance, still used four-track machines when recording *Sgt. Pepper* by the Beatles in 1967). In addition, Joe Meek's experimentation with the studio technology on the concept album *I Hear a New World* (1959) and Phil Spector's layering of instruments—what came to be known as the wall of sound—are some of the techniques that came to influence a number of the more creative approaches to recording that emerged during the 1960s. Ulrik Schmidt (2013) describes how Spector's aesthetics of sound highlights

a giant step away from reproduction toward production. Spector deliberately sought to "erase" (or even out) the specific qualities of individual instruments (that is, the real-world characteristics of the instruments) to, instead, prepare the instruments for a particular mediatized appearance—and this caused a new and enhanced attention to the aesthetics of the mix as opposed to the performance.

It was perhaps George Martin's work with the Beatles and Brian Wilson's productions with the Beach Boys in 1966–1967 that most emblematically turned the recording studio into a site of artistic creativity. Edward Kealy (1979) has described this change as a consequence of the social restructuring that took place in recording studios in relation to new technological developments. These developments, he says, resulted in two overall tendencies in music recording by the end of the 1960s. First, several sound engineers sought to establish a more collaborative role, taking a greater part in the artistic process of making the recording, and, second, several musicians started to take part in the actual process of recording and mixing. This increasing overlap between the traditional roles of engineers and musicians eventually came to make recording technologies tools for artistic expression. The recording studio became a place where sounds were designed and made to "fit" the recording medium in order to create a specific listening experience—it became a compositional tool, as Brian Eno (2004) called it.

Events such as these point to a change in the overall discourse. Whereas the old discourse resulted primarily in a construction of similarities between recordings and the real (the ONE REALITY metaphor), the "new discourse" resulted in a construction of differences (the MULTIPLE REALITIES metaphor). An example further highlights the latter discourse: When the Beatles stopped playing live concerts in 1966, one of the purported reasons was the fact that they could no longer re-create the desired sound quality of their recording on stage. Their tracks obviously were highly edited in the studio, but that was not in itself the problem. The real issue was that the sonic traits of studio editing in their tracks formed an essential part of the tracks' identity. Cunningham (1996) notes that "the recorded repertoire had become so intricate that it was impossible to recreate it live as a four-piece, and therefore [the Beatles] were forced to playing old hits such as 'I Feel Fine,' which had no bearing on the colourful new sounds being cultivated in the studio—the only place that now mattered" (p. 146). The decision to stop touring, then, can be seen as both a contribution to a new status for recordings and as a consequence of the shifting aesthetics of recorded music. Recordings should not capture the sound of the Beatles performing live. The Beatles should ideally be able to re-create the sound of the recording in a live situation.

With the advent of 16-track tape recorders and, soon thereafter, 24-track recorders in the early 1970s, artistic creativity in the recording studios flourished even more. Cunningham (1996) describes how the technology offered the sudden ability to heavily process individual sounds:

> The additional flexibility given to engineers through the use of sixteen-track machines explains the sudden clarity of rhythm tracks, particularly drums, which came to fruition in the early Seventies—a period when strict close miking was the order of the day and little or no room ambience would creep into the mix. (p. 176)

Having each instrument on its own track allowed engineers to pan each sound to a unique position. Individual drum sounds, for instance, could be spread out across the entire stereo spectrum, and guitar tracks were often split in two in order to pan them to each side. In their analysis of the spatial configuration of sounds in 1,000 songs recorded from 1965 to 1972, Ruth Dockwray and Allan Moore (2010) show how panning conventions changed rapidly with the invention of 16- and 24-track recorders (see the Balance/Unbalance entry in Chapter 4). Although stereo was first invented in order to make recorded sound more like actual (real-world) sound, it became a means of enhancing the spatial qualities beyond the real in the 1970s. New technologies and new practices in the recording studios such as those mentioned here paved the way for the continuous rise of a new sound aesthetics that came to endorse the characteristics of virtual spaces rather than actual spaces and thus made possible the gradual emergence of a discourse focused more on qualities of the recorded sound itself rather than sound qualities of the real pre-recorded sound source.

The Aesthetics of "Inferior" Sound

Rather than exploring further how new technological advances came to support this discourse (see instead Cunningham 1996; Milner 2009; M. Katz 2010), I will argue here that the new status of recorded sound paved the way for the emergence of an aesthetics of *lossy* (compressed data) sound formats.

In a 2001 article in *Billboard* titled "Digital Files' Quality Suffers" (Saxe 2001), a number of audio professionals are interviewed about the MP3 format. One of the respondents, Walter Sear of Sear Sound Recording in New York, expresses worry about the corruption of a whole generation that has become accustomed to "garbage" quality:

> We now have a rather indifferent audience out there. They don't stay with any song or group for more than six months, and part of it is the fact that the sonic quality is so poor. MP3 is just another step down. (Sear, quoted in Saxe 2001, p. 77)

Similar thoughts are uttered in academic studies of music formats. In 2010 Mark Katz wrote that we now live in the age of "post-fidelity,"[6] when convenience is appreciated more than quality. In an attempt to foresee the future of the fidelity concept, Katz lists three possibilities:

> One is that post-fidelity marks a turning point in which recorded sound diverges in ever more pronounced ways from its erstwhile model: live music. Another possibility is that the post-fidelity age is temporary, and that further advances will bring about a new hi-fi age. A third possibility is that the concepts of fidelity and convenience lose their distinctive and oppositional meanings. If music never leaves our side, the concept of convenience as a special value will be rendered meaningless; at the same time, high-quality sound (however that is defined) will require no particular effort to obtain or access, and it, too, will no longer be a particularly meaningful concept. Whatever happens, we will one day look back at the turn of the twenty-first century as a period when good enough was—for the first time in the history of recorded sound—good enough. (2010, p. 219)

I am not capable of predicting the destiny of any audio format (that would be worth an economic investment in specific technologies), but if we look to other media that were not introduced for reasons of good sound—such as the cassette—we will find similar debates, and this may give us some idea as to what to expect from the future of other lossy formats. Like the MP3, the cassette, launched by Philips in 1963, was not hailed for the specific character of the sound, but it offered users a way to record music from the radio and share music with each other at low cost. Retailers were keen to tell their customers that the medium was reliable and durable and that the sound quality (the worth of the sound) was not as bad as one should think. No effort was made, however, in the period after its invention to describe its specific sound qualities—which would allow users to appreciate the medium for its sound quality rather than its physical size, playback time, and durability—in positive terms.

In the beginning of the 1970s some attempts were made to change this discourse. The November 7, 1970, issue of *Billboard* devoted 30 pages to articles about the cassette under the section heading "The Cassette Story" (Weber 1970). "For five years many have talked it down. Or wished it would go away. But cassettes are too important to overlook" (p. 38), Bruce Weber writes in the

article. The claim was that the cassette had reached a level of sound quality that allowed its convenience to outweigh its shortcomings. It was acknowledged that the sound quality of the cassette was inferior to that of vinyl, but at the same time it was emphasized that recent improvements such as integrated Dolby noise reduction in many playback systems demonstrates that cassettes were ready for the hi-fi market. At the start of the decade the medium was mainly used in cars, while the Sony Walkman, introduced in 1979, and the boombox paved the way for its survival into the 1980s, still with a focus on convenience and portability as the medium's main assets. Yet the early 1980s also saw a growing market for hi-fi tape decks, mainly to allow users to play their mix tapes with the best possible quality.

Although few people today would choose the cassette for its convenience and portability, the medium is still alive in niche communities—not in spite of but because of its sound quality and the feelings of nostalgia that this sound produces. In a discussion on Steve Hoffman's Music Forum starting in 2009 and ending in 2017, a user asked for other users' opinions of the sound quality of the cassette: "Hi Folks. What's the consensus on how a compact cassette compares with a CD, in terms of sound quality?" (user: FieldingMellish).[7] The responses can be divided into two broad categories. First, there are those who found that the cassette is inferior to vinyl but definitely better-sounding than the CD:

- In my experience, vinyl to cassette sounds very warm. Even a CD transferred to a cassette sounds warm. A great way to "smoothen" up a bright, harsh CD is to record it to a cassette. (user: slunky, 2009)
- Cassette over CD for me. I put on a cassette, I feel good. I put on a CD I get distracted or annoyed. That's in general of course, but a cassette makes me feel like a pleasant drug is coming on—like I "get into" the music. Not true with a CD. Can't give a scientific reason but it's more pleasant. (user: Steve G, 2009)
- It sounds like a record sounds: fat, lush, warm, heavy bass, etc. In other words, no digititis. (user: peter, 2014)
- When I listen to CD's, I often hear a perfectly clear sound. When I listen to cassettes on a decent cassette deck, I hear a "perfectly" natural and authentic sound. Along with some slight hiss during the quieter sections. I know digital is supposed to reproduce something totally and completely. But I don't know any music that sounds that clear in real life. (user: DRM 2017)

Second, there are those who thought that the cassette is and always has been inferior to the CD. The reasons for this claim were many, but users often

pointed to technical limitations such as noise issues, hiss, flutter, and narrow frequency response:

- Aside from the portability, cassettes were awful (pre-recorded in particular). I still have a number of personal dubs from LPs that are very pleasant to listen to, but really I think CDs have it all over cassettes in terms of sound quality and convenience. I still remember the horror of a favorite tape getting "eaten," the tape getting stretched, the hassles of fast forwarding and rewinding. It's my opinion that my more recent efforts at capturing LPs -> CDs sound much better than my cassettes ever did. (user: wgriel, 2009)
- CD anyday for me. Tape hiss, even with TDK SA, was always an issue. Tape fragility too. Sound quality wise, CD again. The tapes went a long time ago. (user: Brother-Real, 2015)
- Can I please, for the sake of my sanity, implore everyone not to start a "cassettes sound better than CD because they are analog" movement. The format was invented for dictation machines. The application of cassettes for hi-fi use was one of [the] greatest crimes against good sound ever committed. Yes, cassettes are analog. That doesn't mean they sound good. The tape is too narrow, too thin and the tape speed criminally slow. Low tape speed means hiss, poor frequency response, endless dropouts and painfully high wow and flutter. The construction of the cassette also meant that no cassette ever played back with the correct azimuth alignment twice, causing phase errors between the two stereo channels. Let[']s bury this format and make it the relic of history it deserves to be. (user: David756, 2016)

It is not surprising that the proponents of the cassette point to the more metaphorical qualities of the sound ("warm," "natural," "smooth," and so on) while those who hold that the cassette is inferior—as a fact—point to its technical limitations. The cassette lovers need arguments that move beyond what are considered verifiable characteristics of the sound quality; they need the metaphor. The arguments arise within the MULTIPLE REALITIES metaphor and thus outside discourses that take the struggle for perfection as an essential component. We are presented with two opposing discourses constructed in the process of debating the worth of a sound format.

The worry that listeners in the age of MP3s will become indifferent to sound quality (as an overall standard for "perfect sound") is also addressed by Jonathan Berger. Berger, however, is not deeply bothered about the prospects for a new sound aesthetics fostered by the lossy formats: "Some like the Sizzle and others like the Crackle," Berger says (in a radio interview by Dougherty 2009, n.p.), subverting the common discourse about good and bad quality.

Users often report negative attributes of low-resolution MP3s such as harshness, a metallic quality, or lack of brightness. Yet the MP3 is likely to be—or will be, when a new generation (of YouTube viewers and so on) becomes accustomed to low-resolution lossy formats—appreciated for its distinctive characteristics in the future by people who like "the sizzle" and who may connect the sound to specific genres and artists or who may just find the sound nostalgic. Although future MP3 aficionados probably will only account for a limited number of listeners, they may engage in debates and—once again—stir changes in language and lay the ground for changing listening habits.

Concluding Remarks and Summary of Main Points

Whereas our cognitive system provides a foundation for thought and language and thus provides some stability and predictability to cognitive processing over time, our cognitive system also adapts and develops in relation to changes in context (e.g., historical, cultural, and technological). In this chapter I have argued that metaphors can be seen as key framing devices that define or modify a specific discourse over a certain time span. The concept of sound quality has evolved in tandem with both social and technological processes, and I have proposed that the discourses of sound run through a number of phases in the history of recorded sound. In order to make sense of how metaphors of sound and the wider discourses of the sound quality of recording emerge, I treated the period of the invention of the phonograph as ground zero where the lack of a framing metaphor for recorded sound was a key feature of the discourse of sound—or, rather, the lack of such discourse. I then exemplified how the metaphor of realism and later the metaphor of multiple realities developed or were socially constructed in relation to the inventions of new audio technologies.

Specific discourses of sound limit the kind of meaningful questions we may ask about sound and the rational responses we may have to a heard sound. When and if recorded sound is evaluated in relation to the concept of realism, questions about a sound's roughness, balance, or thickness are unlikely to occur because the sound quality will always and only exist somewhere on a continuum between the realistic and the unrealistic. Only when discourses are framed around a pluralistic worldview, in which the striving for one perfect real reality is replaced with an acknowledgment of multiple forms of realities, does it become possible to evaluate and appreciate characteristics of the sound that belong to the sound itself, and not to its imagined pre-recorded counterpart.

The interrelatedness of thought, language, and auditory experience in our cognitive system may allow us to study further how listening competencies adapt to discourses of recorded sound. We should be careful, however, in making prophecies about the competencies of the next generation of music listeners. Prophecies such as the claim that listeners will become (or are becoming) "indifferent" to sound quality make sense mainly within the ONE RE-ALITY metaphor—the belief in one future, ideal end goal for recorded sound, a discourse kept alive by (among others) the audio industry. We could just as well argue that some listeners' conscious preferences for so-called lossy formats instead of "full audio" (notice how the concepts contribute to the construction of normative values) should be acknowledged, exactly because they are framed within a discourse of "multiple ideals," a discourse in which sound quality should be understood as perceived characteristics of the sound itself rather than the implied worth of the sound in relation to an imagined reality. This could be a sign that the good/bad continuum as an overall standard is getting weaker, the term *perfection* in the sound and music industry is challenged, and that—in line with the first of Mark Katz's three possible futures—recorded sound quality will, in fact, diverge profoundly from its realist model.

2
The Ontology of Recorded Sound

In the previous chapter metaphors were presented as essential to human understanding, and it was argued in the introduction that metaphors serve as analytical tools with which to understand and conceptualize the quality of recorded sound. In this chapter I expand on this mode of thinking and argue that our metaphorical system governs how we understand the more fundamental nature of sound's being in the world. Thinking and communicating with metaphors involves assigning a basic status to sound. This metaphorical delineation of sound has three major roles:

- to make sense of sound in experience
- to communicate auditory experience
- to sketch possible ways in which we may interact with sound

I situate metaphorical descriptions of sound within a discussion of existing definitions of sound found in various musicological and philosophical works. These discussions relate to the history of sound and music technology (dealt with in chapter 1), topics that have come to have a great influence on our understanding and conceptualization of sound.

Let us look at a few examples of the way language that is used to describe sound provides clues to our thinking about what sound is (metaphors in italics):

- The fewer instruments in the mix, the *bigger* each one should be. Conversely, the more instruments in the mix, the *smaller* each one needs to be in order for all to fit together. (Owsinski 1999, p. 30)
- The record has a *warm* analogue feel. (Stosuy 2011, n.p.)
- Their beats are *solid* and *captivating* enough that they should be able to expand sonically without *surrendering* their *stable core*. (Masters 2011, n.p.)
- It really came *alive*, because his voice was able to *fight* through all the stuff that was going on and make it personable. (Brauer, cited in Tingen 2008a, n.p.)

These quotations represent different descriptions of sound quality. On closer inspection, we find that certain aspects of sound's status in the world

Making Sense of Recordings. Mads Walther-Hansen, Oxford University Press (2020). © Oxford University Press.
DOI: 10.1093/oso/9780197533901.001.0001.

are presupposed. For instance, in the first excerpt we find a reference to the sound's size—"bigger," "smaller"—and in the next two we find references to the sound's warmth and solidity. In the source domain (see chapter 1), size, warmth, and solidity are qualities of physical objects. When these qualities are mapped onto the target domain we map both the quality itself and the more general category "physical objects" onto sound. The underlying cognitive metaphor *objectifies* sounds in experience. It transfers a fundamental structure of being to sounds that allows us to think of them as something we can handle like physical objects. In the final quotation, the descriptors "alive" and "fight" point to a slightly altered take on sound in which animate characteristics and actions are transferred to the auditory domain in order to make sense of sound. The point is that, when we ascribe qualities to recorded sound, we not only characterize certain properties of the sound but also, more fundamentally, characterize what the sound is. The metaphorical transfer of meaning from the *source* to the *target* domain simply bears with it a certain view of the way sound exists in the world for us.

This chapter focuses not on the qualities of sound but on what these qualities are qualities *of*. What are the general features of the sounds we perceive when we listen to recorded music, and how do these feed into our perception of qualities that then form the foundation of our metaphorical thinking? As we shall see, there is a complex relation between the act of listening and the object of listening (what I call the *sound gestalt*), and I argue that metaphors serve to reduce the complexity of this relation in a way that makes sound a graspable concept.

In chapter 1 we saw that metaphors are central to discourses of sound. But how do these discourses lead to new definitions of sound? I argue in this chapter that we conceive of the general *being* of sound by means of metaphor. Metaphors are not only decisive for how the quality of sound is conceptualized, but also what sound *is*.

In the act of listening to recorded music we, quite sensibly, take sound for granted, but the sounds we listen to exist for us in different ways. Its *nature of being*, often referred to as the *ontology of sound*, is connected to the qualities of the sound and how we listen to it. But why are these more fundamental structures of sound conceptualization important to understanding how we make sense of sound? In order to answer this question, I will illustrate the kinds of sound ontologies that emerge from language and the ways in which they reflect how we make sense of sound on the level of thought. I then tie these *ontological metaphors* to definitions of sound that emerge from musicology and philosophy to further advance the status of metaphors in music listening and music production.

Ontological Metaphors

Ontological metaphors are specific variants of cognitive metaphors. They exist at a basic level of our cognitive system and are not always as easily detectable in language as are many of the more structural metaphors (i.e., metaphors that provide more specific characteristics to the target domain). The idea that ontological metaphors exist as basic structures of abstract thinking arose with Lakoff and Johnson's work (1980; Lakoff 1987; Johnson 1987). Lakoff and Johnson claimed that ontological metaphors function as a way to "pick out parts of our experience and treat them as discrete entities or substances of a uniform kind" (1980, p. 25). The primary function of ontological metaphors is to allow a deeper understanding of a number of abstract phenomena such as the mind, love, life, knowledge, or price. There is no simple way to handle these concepts and talk about them in literal terms. But once we start to think of these concepts as discrete entities, they become manageable to us in different ways. We may, for instance, subject the concept "knowledge" to categorization and quantification (e.g., "no knowledge" or "a lot of knowledge"), and we may refer to specific qualities of people's knowledge or identify causal relationships between knowledge and other domains (e.g., "lack of knowledge caused the financial crisis").

Thinking of sound as a set of discrete entities (e.g., as physical objects) gives a delineated structure to sound. This delineation is generally broad and unspecified because typically we do not know what kind of object is meant. Ontological metaphors should be seen as sorting mechanisms that provide us with basic categories into which we can allocate our experiences to make sense of them and to allow for communication of these experiences. The puzzle is to identify the essential properties of these basic categories. What are the fundamental features of objects that are mapped onto sound when we think of sound in terms of physical objects (e.g., "the sound was solid and round")? And how can something unspecified function as a source domain for metaphorical thought?

Lakoff and Johnson (1980) refer to *personification* as a specific kind of ontological metaphor in which nonhuman entities are understood as human. Many of the characteristics and actions used in the description of sound, however, are not confined to humans. I, therefore, prefer the term *vivification* to make sense of the way sounds are sometimes understood as animate entities. Such an understanding is reflected in the following expressions:

- The sound *hit me.*
- The sound was *acting strange.*

- The sound *came alive.*
- The sound *went dead.*
- The sound *lifted me up.*

One may argue that we can easily understand the meaning of each of these expressions without reference to the overall ontological metaphor SOUND AS ANIMATE BEINGS. Most people have come across similar expressions before, and we know how to decode and make sense of them. But what about more innovative extensions of these metaphors that we have never heard before? Consider first these made-up expressions: "The sound picked me up and threw me back against the wall," "The sound invites me to coffee and cake," "The high frequencies are drowning in the paddling pool," "The guitar sound is gaining too much weight and needs a diet," or "That sound is built of straw, not concrete." These expressions will probably appear strange to most people. Still, we are capable of making some sense of them. Yet without the overall ontological metaphor SOUND AS ANIMATE BEINGS these expressions would be complete nonsense. Certainly, it takes slightly more cognitive effort to decode such innovative statements, but the fact that it is possible supports the claim that they are governed by the same metaphorical system as are more conventional expressions. There is a qualitative difference between being invited to coffee and cake and being thrown back against the wall that we use to make sense of these sentences in the context of auditory experience, and this understanding is regulated by the overall ontological metaphor.

Lakoff and Johnson take ontological metaphors to be "so natural and persuasive in our thought that they are usually taken as self-evident, direct descriptions of mental phenomena" (1980, p. 28). But although they find that ontological metaphors serve only a very limited set of purposes, the cognitive function of these metaphors is deemed important in a number of scientific and practical domains. In computer interface design, for instance, ontological metaphors are often seen as imperative; they make possible a certain mode of thinking. Barr, Riddle, and Noble (2002) argue that ontological metaphors allow quantification of otherwise abstract objects in graphical interface design. As an example they point to the computer file—a collection of binary data that is objectified in thought. Because this is so, we are allowed to talk about the size of the file and its location. Likewise, ontological metaphors are used extensively in sound interface design. Bakker, Antle, and van den Hoven (2009) found that the activity of manipulating physical objects helped children learn abstract musical concepts such as pitch and dynamics. Their experiments showed that children could structure their understanding of musical concepts in bodily movement and

manipulation of tangible objects before they could verbalize them. In addition, Roddy and Furlong (2013) found that metaphoric reasoning should be integrated more fully into the design of auditory displays because designs for interaction that reflect embodied metaphors are more intuitive to operate than those that do not. Kirk Pillow (2003) is slightly more circumspect in his view of the role of ontological metaphors. Pillow writes that they "condition opportunities for valid aesthetic reflection at an empirical level" (p. 279). He then argues that metaphors do not entirely determine our actions and thought, but they motivate and guide us.

Clearly, no one metaphor captures experience in its entirety. It is, for instance, just as valid to talk about sound as substance (e.g., "the sounds blended perfectly into the mix") as it is to talk about sound as physical objects (e.g., "the sound was round and sharp"). But focusing on one ontological metaphor draws our imagination toward a plausible range of meanings that may guide our response to an auditory experience. A historical example serves to underline this point.

The Sound Object

Ontological metaphors give sound a certain status and thereby allow us to make sense of and interact with sound in specific ways. Several studies—for instance, studies of sound interaction systems for children as presented by Antle, Droumeva, and Corness (2008) and Bakker, Antle, and van den Hoven (2009)—supports the belief that ontological metaphors are applicable to structure our experience and understanding in listening and interaction with sound, and metaphor theory is increasingly an integral part of interface design. In order to further support the thesis that these metaphors reflect how we make sense of sound in record listening and interaction with sound in music production, I will illustrate how the status of sound has changed in relation to new audio technologies.

Starting with the integration of recording technology into compositional practices in the 1940s, the French composer of electro-acoustic music Pierre Schaeffer played a key part in redefining the ontology of recorded sound. As one of the first composers (he was, in fact, trained not in music but as a radio technician) to write music by editing recorded sound on the newly invented tape recorder, Schaeffer found that existing concepts of sound and music did not reflect his compositional thinking. Schaeffer's approach to music making was to record everyday sounds onto tape that he would later cut up and rearrange in his studio. The traditional music vocabulary, centered mainly on the

concept of tones, had little relevance in this practice, and for this reason he coined the term *sound object* as a means to define the sensory unit of his music.

Schaeffer's proposal of the sound object was motivated in large part by a wish to make the perception of sound, in all its complexity, an integral part of music theory. He felt that music theory focused too much on notational parameters of music such as pitch and harmony. What was missing was a theory of sound that would allow us to understand its aesthetic potential in musical compositions. In Schaeffer's book and audio box set *Solfège de l'objet sonore* (1967), which accompanied his major theoretical work *Traité des objet musicaux* (1966), he attempted to introduce ways to categorize and describe the different qualities of sound. As the title suggests, Schaeffer thought of his method as a way to rethink the solfège system. The traditional solfège system is designed to improve the recognition of pitch intervals; this is achieved by, among other means, assigning syllables to particular notes of a scale, often accompanied by hand signs. In Schaeffer's rewriting, solfège was about determining the difference between recorded sounds, and between the continuous variations in recorded sounds, in order to arrive at a new typology of sound qualities.

Following this chapter's discussion about ontological metaphors, we notice how the term *sound object* implies a specific form of being. From the perspective of cognitive linguistics, the sound object is itself an ontological metaphor. It is a concretization of sound that allows us to understand and make sense of its properties in terms of physical objects such as its shape and size. We may further argue that the term *sound object* is an explicit ontological metaphor that functioned, at least for Schaeffer, in a very conscious manner, insofar as he was able to use it in practice and theorize about it at the same time. As Wong (2012) has noted, there are no indications that Schaeffer ever thought of the sound object as a metaphor. Rather, it seems that he saw it as an actual sensory object, and he referred to it as "an organized unit which can be compared to a "gestalt" in the psychology of form" (Chion 2002, paraphrasing Schaeffer, p. 32, emphasis in original).

The sound object is a regulative concept in the sense that it prescribes certain thoughts and actions in relation to sound. The value of this concept in interaction with sound becomes even more apparent if we consider what it does *not* allow us to do. Thinking of the sound object as an ontological metaphor (knowing that Schaeffer did not), we see how the concept precludes from experience aspects that are not framed by it. We can illustrate this point by proposing an alternative ontological metaphor such as SOUND AS AIR. Although we may shape physical objects and move them around, air does not possess these potentials for interaction in the same way. We cannot, for instance,

locate air (it is all around us), and we cannot normally grasp it physically. We see, then, that the metaphor SOUND AS AIR changes the potential ways in which we may interact with sound. In music production, the notion of control of the material is typically essential. There are very few things we can do with air and quite a lot we can do with physical objects. The latter are, at least to some extent, controllable—shapeable, moveable, and so forth—and therefore are valued as building blocks for artworks in any sensory domain.

In the following section I shall review some of the dominant definitions of sound that are derived from philosophical and musicological works. The purpose of this review is not to arrive at one correct definition of sound but to point out how these definitions are reflected in different ways in the everyday language of recorded sound.

Listening to What?

In order to distinguish between listening in the actual world and listening to recordings, John Garas (2000) differentiates between what he calls "natural spatial hearing" and "virtual spatial hearing." Natural spatial hearing is connected to our everyday life in that we estimate the characteristics of our acoustic surroundings and search for the location of the sounds we hear. Although we primarily use our eyes to locate things in front of us, our auditory system is important in orienting ourselves when we move around and when things move around us. For example, we use our ears to determine that somebody is approaching us from outside our visual field.

Listening to recorded music, on the other hand, is an instance of virtual spatial hearing. We do not need to respond to the location of particular sound sources in the same way we do in the actual world. Still, the perceived acoustic environment of the recording and the felt location of sound sources have an impact on our experience—they affect us. The most obvious and, perhaps, most fundamental feature of listening to recordings is the fact that the original sound-producing event is not visible to the listener. The term *acousmatics* has been used extensively in writings about electroacoustic music in order to theorize this feature of listening to recordings. The French writer Jérôme Peignot reintroduced the term (from Pythagoras) in 1955 (see Kane 2014) to define the changing relation between listener and sound source that emerged with recording technology. *Acousmatic* simply refers to sound whose source is hidden. It alludes to a tale about Pythagoras, who lectured in such a way that a number of his students called *akousmatikoi*—who were not yet entitled to *see*

his demonstrations—were seated behind a veil. For these students the actual sound source, Pythagoras, was concealed, and they were therefore forced to develop a certain kind of concentrated listening (Kane 2008). The veil, then, functioned as a physical rupture between the visual source and the receiver.

This anecdote was appropriated by Schaeffer (1966) to describe the process of listening to recordings, which entails listening to sounds without seeing their sources. The veil is thus a metaphor for the process of recording. To record an actual sound source is to remove its visual calling card. This removal then *releases* several potentials for hearing the sound in new ways, as our perception of the sound is no longer guided by what we see. These potentials can be roughly summarized in two ways:

1. the potential for sound to trigger our imagination and create new ideas about its cause that may hold little or no relation to the actual (real-world) sound source
2. the potential to foreground the sound-in-itself in perception by removing any causal relation to an imagined or actual sound event

Schaeffer (1966) and later Roger Scruton (1999, 2009), hold that only the second potential applies to hearing recorded music because they believe that this mode of listening detaches sound from its (imagined) cause. Others, such as Eric Clarke (2005) and Simon Emmerson (2007), argue that the sound source cannot be removed from imagination in music listening. Clearly, it makes little sense to argue that a sound is experienced as being solely a sound-in-itself detached from its (imagined) source while, at the same time, being solely its source. But it makes sense to see each of these sound categories as conceptual elements of the same overall sound gestalt—elements that are present for us in listening as latent structures that may be activated (pop out) in different situations. Before I return to this argument—that sound has a shifting status in experience—it is worthwhile examining each of these definitions of *sound* separately.

Sound-in-Itself

Some scholars argue that musical sounds are heard as detached from their physical cause. Roger Scruton (2009), for instance, suggests that musical sounds are heard as pure events or secondary objects. According to this view, sounds are not perceived as properties of the sources that emit them but as objects in their own right. Scruton exemplifies this as follows:

A car crash is something that happens to a car and the people in it. But a sound is not a change in another thing, even if it is caused by such a change. Nor does anything participate in the sound in the way that the car participates in the crash. (p. 50)

Sounds, in the form of pure events, are not the objects that emit them. The car participated in the crash, not the sound. In perception, the sound is an event in itself, a pure event, distinct from the source event of the car crash. A sound source event is perceived as something that has a real existence in a certain point in space. We imagine that it would be possible to walk to the source of the sound in the actual world and confirm that it was really there, where we believed it was located. A pure sound event, on the other hand, does not exist for us in any exact location in space. Nor does it refer causally to anything in the actual world. It is perceived as a sound-in-itself.

This view is closely related to Pierre Schaeffer's claim that the acousmatic situation is a prerequisite for a new mode of listening in which the sound-in-itself gains importance over the sound source. He called this form of listening *reduced listening*, suggesting that the listening experience should rule out any relation to the sound's origin to focus only on the sound-in-itself. Schaeffer recognized that we are naturally inclined to attend to sound sources; we should therefore make an active effort to remove the sound source from experience in order to increase our appreciation of music. Reduced listening, then, is seen as an enhanced form of music listening. Scruton, however, has a slightly different notion of acousmatics. For Scruton music listening itself is an acousmatic situation. We do not need to remove the visual elements from perception in order to remove them mentally. Once we start to hear sounds as music we stop listening to sounds as sound sources. In this way Scruton uses the notion of acousmatics to distinguish between musical and nonmusical listening. We do not have to learn to listen in a reduced manner, Scruton claims; we unwittingly start to listen to sounds-in-themselves when we start to hear sound as music.

Focusing on the sound-in-itself in music analysis poses a considerable challenge. Several scholars have pointed to the lack of an adequate language to describe the qualities of the sound-in-itself. Barry Blesser and Linda-Ruth Salter (2007) states that there is no natural language to describe it, while Michel Chion (1994) suggests that we may determine only pitch structure in the sound-in-itself because pitch, according to Chion, does not relate to the sound source. This, however, is not entirely true. Pitch is often one means to determine what kind of instrument is playing. Think about the difference between a guitar and a bass guitar. If you pitch the former down it will come to

sound much like the latter. The same goes for string instruments. Chion further claims that "present everyday language as well as specialized musical terminology are totally inadequate to describe the sonic traits that are revealed when practicing reduced listening on recorded sound" (p. 31).

Sound Source Event

Some scholars have argued that sounds are identified in listening as temporal events connected to vibrating objects that set a surrounding medium in motion and that this apparent sound source forms part of our immediate experience of the sound (O'Callaghan and Nudds 2009). Eric Clarke (2005) argues that auditory perception is fundamentally exploratory. He holds that we do not approach everyday sounds and musical sounds as inherently different from each other. Whether sounds are musical or nonmusical, recorded or not recorded, central to our perception is *what the sounds are the sounds of.* We seek information about what is going on: What kind of event is taking place, and what kinds of sound-producing objects are involved? When we do this, the acousmatic situation may actually intensify causal listening. Simon Emmerson (2007) agrees with this hypothesis, writing: "Most music now heard appears to present little evidence of living presence. Yet we persist in seeking it out . . . we attempt to find relationships between action and results" (p. xiii). This statement is linked to Emmerson's belief that all musical experience is a product of musical performance. Whereas traditional performances, where musicians can be seen, do not encourage the listener to mentally search for the sound sources because they are visually present anyway, the acousmatic situation results in a new aesthetic involvement—one in which the physical division between the recorded sound and its actual (real-world) source teases the listener's curiosity.

My own approach is informed by a pragmatic position, accepting that there are different kinds of explanations as to *how*, and to *what*, we are listening in different situations. No sound is perceived merely as a reference to its source, and no sound is perceived only as a sound-in-itself; the musical experience includes both of these in its sound gestalt. Andy Hamilton (2009) presents a viewpoint closely related to my line of reasoning. He argues for a dual position suggesting that recorded music listening has both a literal and a metaphorical dimension. Musical sounds, he claims, can take different forms in the same way a painting can represent both internal forms (e.g., shapes and colors) and external forms (e.g., persons and things). *The* external forms in music listening are usually tied to the perceived performance event. Musicians and

instruments literally move in order to produce sounds, and we experience these physical events (or an idea of these events) when we listen to music. Internal forms reside on the metaphorical level. Rhythms move, tones lead to other tones, and sounds morph into other sounds.

I will take this argument one step further and claim that the metaphorical and literal dimensions merge in experience and form a sound gestalt. We see this sound gestalt addressed most clearly in descriptions of sound quality in which both the sound source and the sound-in-itself are implied, such as "the guitar is *dry*." This expression does not imply that the guitar lacks water in any literal sense, nor does the phrase represent a literal description of the sound source with a metaphorical twist. Instead, I suggest, we make sense of this expression because the word *guitar* represents the sound as a whole (i.e., they are in a metonymic relationship—see Kövecses [2002]), and the judgment of sound quality (dry) points to this sound gestalt. To be clear, the guitar (the perceived source) provides mental access to an overall sound gestalt because it is understood within the same conceptual domain. The sound gestalt does not represent the guitar; we either hear *the guitar in the sound* or *the sound in the guitar*, and our metaphorical system—and more specifically the ontological metaphors—serve to regulate any aesthetic judgments we may make about the quality of the sound by mapping a concrete value onto it.

Recorded Sounds Are Physical Objects

> When we act we do not always explicitly think of the 'higher' regulative concepts with which these rules are associated. The way practice works is not necessarily identical to how people think it works in their day to day activities. Persons tend to think globally only when encouraged or forced to do so.
>
> **L. Goehr,** *The Imaginary Museum of Musical Works*

Listeners refer to different conceptions of sound when they talk about what they just heard. These conceptions are in turn related to what the listener is listening for, how the listener listens, and what kind of listening the sound stimuli provide to the listener. Although most listeners are not consciously aware of how the ontological status of sound changes during listening, the language we use to describe sound often reflects this change. Evaluating sound quality is largely an unconscious process. In order to make sense of sound, we map physical objects onto the domain of sound. The ontological

mapping from the source domain of physical objects to the target domain of sound is not explicitly articulated. It exists largely as a hidden structure, but it can be detected by looking more closely at the way we speak. In the sound engineering literature, for instance, the metaphor SOUND AS PHYSICAL OBJECTS is easily detectable. Consider the following expressions:

- A lot of my treatments were done to make sure that *everything has its own place*. (Serge Tsai, cited in Tingen 2007e, n.p.)
- The fewer instruments in the mix the *bigger* each one should be. (Owsinski 1999, p. 30)
- The bass and kick drum aren't *locked together* or *big* enough to *glue the record together*. (Joe Chiccarelli, cited in Owsinski 1999, p. 97)
- I really start searching out the frequencies that are *clashing* and *rubbing against each other*. (Jon Gass, cited in Owsinski 1999, p. 31)
- Another way of creating *separation* was through panning. (Rich Costey, cited in Tingen 2008c, n.p.)

There are two points to be made concerning these statements. First, this is not a list of five different ontological metaphors. They are all examples of the metaphor SOUND AS PHYSICAL OBJECTS. For instance, we can see from the expressions that sounds have sizes, that they are physically located in space, and that they interact with each other. Second, the expressions do not *create* the metaphor SOUND AS PHYSICAL OBJECTS but instead *arise* from it. The ontological metaphor provides the cognitive structure that makes us use these particular expressions. The metaphor is already there as a bodily, embedded cognitive structure, forming the way we think and speak about sound.

As we saw in the introduction, cognitive metaphors typically take the form "A is B." "A" is usually an abstract experience and "B" is usually a concrete experience. In the ontological metaphor SOUND AS PHYSICAL OBJECTS, sound—an experienced sensation—is an abstract concept that gets its cognitive structure from the concrete domain of physical objects, while physical objects comprise the source domain we use to make sense of sound. Physical objects do not provide a specific delineation in the mapping; they only provide the idea of an ontological being in the world. As soon as we specify some properties of physical objects, we start to qualify the sound that we describe. We may, for instance, experience and articulate that a sound has a soft quality. In that case, we activate the slightly more delineated, or as cognitive scientists would usually say, more elaborate, metaphor SOUND AS PHYSICAL OBJECTS WITH SOFT SURFACES. Although we may still think of many objects with soft

surfaces, we have limited the number of possible objects considerably. The source domain is no longer the set of all physical objects but is only that of physical objects with soft surfaces. The limitations of possible qualities in the source domain are mirrored in the target domain. If we think of *hard* and *soft* as objectively quantifiable qualities, then, logically, an object that is soft is not also hard. Similarly, if we experience a sound as soft it is not also experienced as hard. The qualities *soft* and *hard* are mutually exclusive in both the source and the target domains. Again, we should keep in mind that these experiences are context-specific and not locked to any physical parameters of the sound signal. A sound may be experienced as hard in the context of a softer sound in the same way we experience wood as hard in comparison to fur but soft in comparison to granite.

Recorded Sounds Are Objects in a Container

We have seen a few basic examples of how ontological metaphors are used in the language of sound, but the implications of these metaphors are virtually endless. If sounds are objects then they can be handled and moved around, they have different shapes, weights, and sizes, and they are subject to gravity, to mention just a few of their properties. At a more general level, we may notice how sounds as physical objects have a spatial existence. They take up positions in space, whether specific points or wider areas. Sound engineers move sounds around in the mix and change their shapes and sizes. Sounds are positioned in relation to other sounds, and sounds may be hidden behind other sounds. In order to account for the spatial placement (or being) of sound in the virtuality of the recording, I will introduce the concept "sound container," meaning a metaphorical container in which sound (the content) is located.

We have just discussed how recorded sounds can be understood as physical objects, objects that are present for us in listening but not present in the same way as a chair in front of us. Similarly, sounds are contained in the virtual space of the recording, but they are not contained in the same way as baked beans in a can. The CONTAINER metaphor provides a schematic structure—a CONTAINER schema (figure 2.1—to the experience of recorded sounds (see Chapter 3 for more on image schemas). The features of a container are an inside, an outside, and a boundary, and it provides a place (in a metaphorical sense) where the experienced sounds exist for us. But it also provides an understanding of the relation between the listener and the sound. The sound is *in* the recording, and we experience it from our position outside the recording.

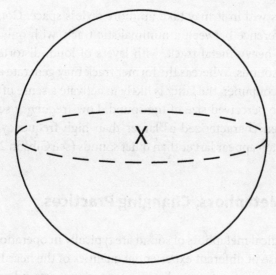

Figure 2.1 CONTAINER schema

The SOUND CONTAINER is there as an ontological metaphor that structures how we think and speak about recordings. Consider the following expressions found in interviews with sound engineers:

- The vocal has to make its entrance *into* the mix as soon as possible. (Owsinski 1999, p. 17)
- The distorted guitars are not featured *in* the track. (Mark Endert, cited in Tingen 2007d, n.p.)
- There were a lot of things playing ... but it made the track too *full.* (Renaud Letang, cited in Tingen 2008b, n.p.)
- I needed a longer reverb to *fill in spaces.* (Jason Goldstein, cited in Tingen 2007b, n.p.)
- If you want something to *stick out*, roll off the bottom. (Owsinski, 1999, p. 33)
- You have these moments *in* the track where it is *open* and soaring and where the big reverbs *open all the floodgates.* (Chris Lord-Alge, cited in Tingen 2007a, n.p.)
- [The sound] *jumps out* of the track too much. (Joe Chiccarelli, cited Owsinski 1999, p. 95)

The sound container is not the media, and its content is not grooves in vinyl or zeroes and ones digitally stored on the CD. It is a cognitive structural principle imposed on the recording. The container may have different characteristics,

and the sounds within it may take up more or less space. Consider, for instance, the difference between a minimalistic track, with only a few sound sources, and a heavy metal track, with layers of loud, distorted, and compressed guitar sounds. Whereas the former track may generate an experience of a partly full container, the latter is likely to activate a sense of fullness. This is related to the perceived size of the sound. Low-frequency sounds, for instance, are often characterized as larger than high-frequency sounds, and loud sounds often appear larger than quiet sounds (see Gibson 2005, 34–35).

Changing Metaphors, Changing Practices

Several ontological metaphors of sound are typically in operation in order for us to make sense of different experiential qualities of the heard sound. If we, as a thought experiment, frame a listening experience around one ontological metaphor, our ability to make sense of this experience is similarly limited. We cannot, for instance, think of sound in terms of the metaphor SOUNDS AS LIQUIDS (e.g., "the sound was swimming around me") and think of sound as firmly located in a specific point in space at the same time. But focusing on one metaphor also has advantages. Although our experiences cannot be reduced to one metaphor alone, we can seek to highlight one metaphor instead of others in order to reduce the cognitive complexity.

In the history of sound production and sonic art we find many examples of new metaphors being promoted in order to change the creative reality of sound editing. The term *sound sculpting*, for instance, emerged with the promotion of the analog synthesizer, and the term often occurs in relation to music production or sound editing for films. Sound sculpting is a metaphor that highlights certain features of the sound-editing process, most obviously, perhaps, the artistry involved. It also motivates the artist to work in specific ways, however. Derived from the idea of sculpting physical objects, the metaphor of sound sculpture seems to promote a focus on the space-based domain rather than the time-based domain of sound. Moreover, a number of sonic interaction designs are built around this metaphor (Boem 2013). Sound sculpting, then, is not simply sound editing but a particular kind of sound editing.

Another common term, *sound mixing*, started to emerge in motion picture journals in the 1930s to describe the process of blending the signal from several microphones. A Google N-gram search (Michel et al. 2010) reveals that the term was increasingly used in relation to music production from the middle of the 1960s as more creative processes moved into the studio

and multitrack recording machines developed rapidly (24-track machines were launched in 1972). Edward Kealy (1979) found that the late 1960s also marked a period of changing practices in the recording studio, where sound editing started to become an art form on a larger and more consistent scale than in earlier practice. Kealy emphasizes two main outcomes of these changes:

1. the conventions for aesthetic judgment changed from utilitarian to expressive, and
2. the status of recording studio workers changed from technical to artistic.

Now, what do the changing statuses of sound recording workers and the musical product emerging from studio-based practices have to do with the ontology of sound? They exemplify how metaphors for describing sound editing changed with new practices, and one of the reasons for these changes is technological development. In the MIXING metaphor, sound is a substance that the engineer can blend in different ways into one sound mass—the final track. The MIXING metaphor points to an overall ontological metaphor for sound: SOUND AS SUBSTANCES. In order to blend the ingredients in a meaningful way, the producer may utilize more specific metaphors (structural metaphors) that again may blend in with other ontologies. As an example, Steve Savage (2014) proposes three sub-metaphors to help producers achieve their aesthetic goal: the mix as *a three-dimensional space*, the mix as *a movie*, and mixing as *dress-up and makeup*.

I have already mentioned sculpting and mixing as ontological metaphors for sound. This list could be extended to include others such as *sound painting*, *sound construction*, and *sound morphing*; such instances point to the openness of the concept of sound. That concept, it seems, is under constant development and negotiation, and metaphors, I argue, function as a sort of steering mechanism that helps us navigate despite this lack of a fixed (or neutral) conceptual foundation.

So far, I have argued that sound is an abstract concept that is understood metaphorically and that the most basic metaphors governing our understanding of sound are ontological metaphors. But I have yet to explain why I think of sound as an abstract concept and not as a concrete concept. Although sound in the form of acoustic energy is de facto a physical phenomenon that can be measured, sound as an experienced sensation may take different forms. There are a number of reasons why I think that sound as an experienced sensation should be characterized as abstract, and these reasons have implications for the main arguments of this chapter: that the basic status

we assign to sound changes in different situations, and often sound exists for us in different ways at the same time.

Barsalou and Wiemer-Hastings (2005) describe a number of characteristics of abstract concepts. One of the main differences between abstract and concrete objects, they argue, lies in the time it takes to process the concepts. Whereas retrieving a specific situation for a concrete concept, such as "chair," often takes little time, it often takes longer to process abstract concepts such as "truth." This applies to the concept of sound also. The reason why the concept of sound tends to be difficult to process properly is that the concept is so pervasive in our everyday life that no specific situation immediately comes to mind. Sound "belongs" in a wide variety of situations, and the concept can therefore be difficult to process.

Although Barsalou and Wiemer-Hastings (2005) do not conform entirely to Lakoff and Johnson's claim that metaphors give meaning to abstract concepts, they agree that cognitive metaphors "augment the meaning" of these concepts. They then proceed to discuss what makes for an adequate understanding of abstract concepts. In order to fully know a concept (e.g., "hammer"), they argue, we must not only know its physical properties but also know how it functions in different situations, what kind of agents are using it, what kind of goals are achieved with it, and so forth. In the case of sound (clearly a less well delineated concept than "hammer"), our situational focus often is distributed across a wider range of situations in order to make sense of the concept. In this sense sound is seen as the more complex concept of the two in that it is more difficult to come to grips with its function in all situations. A few of the situations in which we may encounter the concept of sound include crossing a busy road, measuring the perceived loudness in a room with a sound pressure level meter (SPL meter), listening to recorded music, engaging in a conversation, and attending to one's tinnitus. Sound has different semantic values in each of these situations—as a physical source when heard as an approaching car, as a sound wave when measured with an SPL meter, as consumed music, as social communication, and as a mental construction in the brain when heard as subjective tinnitus.

Turning to recorded sound, Paul Théberge (1997) describes how changing technologies and practices in the recording studio led to changing concepts of recording. As an example he points to multitrack recording as a technology that shifted the focus from recordings as a means of capturing an event to recording as a compositional approach in which music emerges from the blending of individual tracks. I agree with Théberge's view that new concepts emerge from new technologies and practices (and vice versa). But I also find that we may see the impact of new technologies and new practices on our

thinking more clearly if we shift the focus from subordinate (structural) concepts of sound to the ontological level of sound.

The point I want to stress is this: New modes of listening, new music, new technologies, new practices in the recording studio, and so forth not only change the concepts through which we structure the sound, but they change the concept of sound itself. If we believe that ontological metaphors structure what sound is in experience, we must also accept that there are several valid definitions of sound and that changing definitions of sound are not necessarily connected to any change in the physical signal or the specific spatial perspective of the listener. Once we engage with the messy and dynamic nature of lived experience, any fixed concept of sound will fall short in capturing what is going on. For this reason, I believe we need a multifaceted and open concept of sound grounded in many different kinds of situations and embodied experiences.

Concluding Remarks

Most of the metaphors used to describe sound quality are used because they intuitively seem to be correct. Even though we (generally) are not aware of the metaphorical nature of our descriptions, they serve as important clues as to how we make sense of sound's being at the level of thought. Some of the findings of this chapter are as follows:

- Sound presents itself in music listening as both *mere appearance* (the sound-in-itself) and the *appearance of something* (the apparent sound source event). These appearances are embedded in the sound gestalt as latent structures that may be activated in listening.
- Sound is an open concept, and thus no definition of sound will capture all encounters with sound. This means that the concept is gradually developing (often in relation to new technologies).
- Ontological metaphors are tools for reducing the complexity of sound in music production and composition (e.g., thinking of sounds as discrete entities allow them to be used as artistic building blocks).
- If sounds are discrete entities, as in the ontological metaphor SOUND AS PHYSICAL OBJECTS, they stand in a spatial (and often causal) relation to each other.
- Ontological metaphors govern valid judgments about sound by providing basic categories into which we can allocate our experiences and that we can thereafter use to analyze sound in a meaningful way.

- Ontological metaphors allow us to make sense of more innovative descriptions of sound.

In this chapter we have seen that different ontological metaphors such as SOUND AS PHYSICAL OBJECTS and SOUND AS ANIMATE BEINGS are often in play at the same time in music listening and production. This apparent inconsistency in metaphorical thought should not lead us to undervalue the role of the metaphor in experience but, rather, to acknowledge that experiences are complex and messy and that a diverse set of metaphors is needed to make sense of these experiences (see also Johnson and Larson 2003).

3

Sound Quality

Reasoning, Action, and Language

In the preceding chapters I discussed how cognitive processing and the conceptualization of sound in language are influenced by contextual factors (e.g., social, cultural, and technological factors). These cognitive processes govern not only how sound quality is assessed but what sound *is* in the act of listening. This chapter continues that discussion while also considering how sound quality is expressed and reasoned about in nonverbal forms. Although linguistic metaphors that point to connections between sensory modalities at the level of language (see the introduction) are important sources of information for the study of how sound quality is cognitively processed, there are still other sensory integration models that are not revealed in language. Auditory sense-making is a multimodal phenomenon and this is also reflected bodily actions and in cognitive processes that extend beyond the body into its environment. The intention with this chapter is to provide the reader with a theoretical foundation prior to reading the entries in the encyclopedia in chapter 4 where specific metaphors are discussed.

Cross-Modality in Thought and Language About Sound

In 2015 my colleague Mark Grimshaw-Aagaard and I conducted a conference paper titled "The Sound of the Smell of My Shoes" (Grimshaw and Walther-Hansen 2015) with the purpose of developing a theoretical foundation for the sonification of smell in virtual environments. The topic clearly was not chosen because of a sudden demand for the sonification of shoe smell (but we are now prepared when that day comes). Instead, the reason for engaging in such an unusual endeavor was to investigate the role of cross-modality in auditory experience in an area where few obvious cross-modal connections exist. Although the interconnection between sound and image is particularly well-mined, and an increasing amount of research deals with sound and tactility,

Making Sense of Recordings. Mads Walther-Hansen, Oxford University Press (2020). © Oxford University Press.
DOI: 10.1093/oso/9780197533901.001.0001.

little work is being done on sound and gustation, and only a few studies on sound and olfaction exist.

Some explanation for this bias can be found in Joseph M. Williams's (1976) classification of synesthetic adjectives. Williams studied how sensory adjectives found in language are transferred from one domain to another. An interesting finding, in the context of this book, is that the domain of sound, together with the domain of color, is the most likely recipient of adjectives from other senses. The source domains for sound often are touch and vision, while gustatory adjectives are used to a lesser degree. Smell, Williams argues, never functions as a source domain for descriptions of sound.

In order to account for the cross-modal link between sound and smell, then, it is necessary to look beyond language and into the role of more fundamental embodied structures governing cognition. These structures are often known as *image schemas*, a term proposed simultaneously in books by Lakoff and Johnson, respectively, in 1987. Building on Kant's idea that imagination is an essential faculty of the mind in that it has a schematic function that allows it to structure thought, experience, and conceptualization, Lakoff (1987) and Johnson (1987) proposed a number of image schemas that often are activated and altered in specific situations, inter alia, to make sense of sensory stimuli, to imagine something, and to interact with the surrounding environment.

In the musical domain the existence of image schemas typically is exemplified using the experience of pitch. The fact that pitch is conceptualized as either high or low implies that the experience of pitch activates cognitive processes that structure pitch in the vertical dimension. This is further articulated when we talk about a descending or rising melody and is graphically represented in the way music is notated. Critics of metaphor theory would probably argue that the up-down continuum is just something we happen to impose on pitch structure in order to organize it and explain relations between notes. According to this view, we could structure pitches in any possible way (e.g., large and small or right and left) without altering the experience of pitch. Yet the near universality of the up-down continuum in the conceptualization of pitch, and the fact that this structuring principle emerged in different parts of the world independently, typically are seen as evidence that image schemas are formed and embodied through previous shared sensorimotor experience—which emerges from the facts that we all have a body, live on Earth, are exposed to gravity, are situated in space, and so on.

I mention Grimshaw-Aagaard's and my study of the cross-modal connection between sound and smell in order to show that a lack of a connection between sensory domains at the level of language does not preclude other

structural connections at the level of cognition. That smell and sound are, in fact, connected can be seen from an experimental study by Belkin, Martin, Kamp, and Gilbert (1997), who found that subjects could consistently map auditory pitches onto various olfactory stimuli. This result suggests that some specific quality of smell, is cognitively structured by a vertical image schema, as is pitch. Chapter 4 presents several other examples. I show, for instance, that concepts such as balance/unbalance and open/close are governed by the activation of image schemas.

Sound and Color

Image schema theory provides a useful framework for understanding how embodied sensorimotor experiences structure auditory experiences, but it is also beneficial to look into how the cross-modal connection between hearing and other sensory modalities is influenced by repeated exposure to the co-occurrence of specific—and often more culturally specific—stimuli. Think of a classic volume unit (VU) meter that displays a red area when the volume level exceeds zero. When the needle reaches into the red area, audio will start to overload (saturate). The red color signals that the *amount* of sound has exceeded the volume of the *sound container*, and this is reflected in the quality of the sound.

Red likewise signals overload in many other domains; for instance, if we say that someone "sees red" it means that someone is boiling over with anger. Use of the color red as a sign to stop can be traced to the mid-nineteenth century, and "see red" as a metaphor for being angry was first recorded about 50 years later. Red has to do with limits, as in the expression "crossing a red line." The VU meter was standardized in 1937 by the National Broadcasting Company with the Columbia Broadcasting System, and the red color was probably implemented owing to its established connotations—*stop*, the *limit is reached*, *overload*, and so on (figure 3.1).

Technologies such as the VU meter teach us that a red sound is a saturated sound, and repeated exposure to this co-occurrence will lead to some degree of perceptual integration of red, loud, and saturated sound. In an experimental study of the perceived loudness of passing trains of different colors, Patsouras, Filippou, and Fastl (2002) provide evidence for this correspondence. The experiment showed that red-colored trains were judged as being significantly louder than green trains. Menzel, Fastl, Graf, and Hellbrück (2008) later confirmed the correspondence between red and loudness in a study using accelerating cars of different colors as stimuli. This suggests, as the

Figure 3.1 VU meter showing the red zone

authors propose, that coloring products that emit sound may modify the perceived sound quality of these products.

Exactly when red came to designate an excess of something or when it became linked with sound is hard to say, but the reinsertion of the correspondence between loudness and redness in the design of audio technologies serves to consolidate this cross-modal link. Studies of people with chromesthesia (i.e., a form of synesthesia in which sound trigger colors) show that they often match pitches to colors, but which specific pitch maps onto which specific color differs from case to case (Cytowic and Eagleman 2009).

Sound and Shape

The connection between sound and experiences in other domains is also implied in the way language sounds are used to describe these experiences. A number of experiments show, for instance, that there is some consistency in the way shapes are named across different cultures, even when the concept used to describe the experience has no lexical meaning. This suggest that the sound of the word itself has a meaning (a *phonosemantic* meaning) that does not relate to the lexical meaning of the word. This can be seen from experiments concerning the bouba-kiki effect, probably the best-known example of a non-arbitrary mapping between language sounds and shapes. When you look at the shapes in figure 3.2 you probably will have no doubt which one is bouba and which one is kiki. Ramachandran and Hubbard (2001) report that 95 percent of people will name the shape to the left bouba

Figure 3.2 The shapes used to demonstrate the bouba-kiki effect

and the shape to the right kiki. What is interesting is the consistency in the answers across cultures. Bremner and colleagues (2013) found that a group of subjects from among the Himba of northern Namibia, who do not have a written language and who are only rarely exposed to Western culture, also used this mapping consistently.

This correspondence between sound and shape indicates that physical shape may serve as a useful metaphorical framework in tangible sonic interaction design. For this reason, the discipline of human-computer interactions has seen an increasing interest in cognitive linguistics. Grill and Flexer (2012), for instance, examined the correspondence between textural sounds (i.e., nonmusical sounds) and visual representations with the aim of developing an intuitive graphical computer interface for the retrieval of specific sounds and categories of sounds. In their study, subjects' descriptions of sound were represented in graphics (color and shape), and this association was tested on another group of subjects to see if they were able to make use of these graphical representations when asked to associate a specific sound with one of five graphics. In this way the authors demonstrated some correspondence between the perceived roughness of a sound and the jaggedness of a graphic representation. Adeli, Rouat, and Molotschnikoff (2014) likewise demonstrated a correspondence between harsh sounds (in this case, the sound of crash cymbals) with jagged shapes and between soft sounds (in this case, the sound of a piano) and round shapes. The study further showed that the color of the shape did not influence the results, which could suggest—as the authors propose—that the correspondence between the tested sounds and shapes remains constant in different contexts.

Although experimental studies provide interesting evidence for the correspondence between various parameters of sound and other sensory perceptions such as the correlation between sound and shape, the vast number of auditory parameters that influence the cognitive processing of sound make most experiments more suggestive than directly applicable in themselves. Experimental data clearly are useful, and—as readers will already know—I make considerable use of findings from experimental studies in this

book. We should be careful, however, not to be fooled into believing that the sciences will, in any imaginable future, provide us with an overview of how listeners cognitively process sound quality and how these processes are linked with language and action in a meaningful way. In order to obtain significant results, researchers minimize the effect of irrelevant variables; for example, in testing the effect of a sound on listeners, researchers will usually minimize the effect of contextual factors not part of the experiment design. When transferred to real-world cases, however, the results of such experiments are often highly questionable.

A few studies, however, integrate the complexity of sound perception into the test design. Knees and Andersen (2016), for instance, study the mental models used by music producers when searching for new sounds in a sound archive. The authors work toward the development of an interface that will allow producers to find relevant sounds in the sound archive of music software by sketching the sound graphically. In the experiment, music producers are asked to illustrate the imagined sound they are searching for, and they are then interviewed about their drawings. Whereas the study can primarily be seen as a preliminary investigation into the potential of sketching as an audio interface, it shows that a greater understanding of the cross-modal link between sound and shape is highly relevant to understanding, first, the mental models activated in users when imagining sound with specific qualities, and second—and this remains to be studied further—how sketching itself forms part of the cognitive processing of the imagined sound. We could speculate that if a sketching interface like the one proposed by Knees and Andersen were implemented in commercial and widely distributed music production software, or perhaps in streaming services as a tool for listeners searching for music with a particular sound quality, it would produce a learning effect over time that would conventionalize certain ways of perceiving and describing sound in language through metaphors of shape.

Auditory Sense Making Extends into the World

One way to account for the complex relation between internal (mental) cognitive processes and external tools (such as music production interfaces) that allow for the realization of imagined sound qualities is to think of the mind and external entities as two components in a *coupled system*. Some specific frame for realizing sound is clearly learned from technology in the act of using it, but interfaces for sound manipulation also function as tools to think *with* and *through* in the act of using them. It is fair to suggest that the external tools

that a sound engineer has at his or her disposal (e.g., knobs and faders on a mixing desk) contribute to the constitution of cognitive processes involved in imagining a sound. An audio interface can both limit the possible sound qualities a user may imagine and aid the imagination of sounds with specific qualities. Clark and Chalmers (2010) would call this close connection between internal and external components an *extended cognitive system*, stating that it is the function, not the location, of thinking that determines whether something is an integral part of a cognitive system. This extended system is activated in a process whereby the self exploits the surrounding environment and things in it (e.g., technologies or other people) or connects with it (using the body or language) in such a way that all components aid in the completion of the cognitive tasks. It also entails that, if external components such as the mixing desk were removed from a sound engineer's sight when he or she is in the process of imagining a new sound, it would be comparable to disabling a part of the brain.

Critiques of the extended mind thesis would argue that the boundaries of this cognitive system in both time and space are impossible to determine. For instance, does the wider discourse of sound that influences how sound qualities are evaluated and imagined at different periods in history count as part of our cognitive system? It would be fair, at least, as I have done in this book, to see discourses as socially distributed thoughts and beliefs that both aid and shape thinking and reasoning (as I illustrate in figure I.1). Listening is always situated within a particular discourse that influences how one would imagine a sound or recall a previously heard sound.

Action and Interaction Metaphors

When interacting with sound, physical actions are used not only to change the sound but to understand the sound. Sound editing is nearly always a kind of trial-and-error process. This may be seen simply as a means to explore different possibilities before deciding on the "best" sound quality in a given situation. But the trial-and-error process could also be seen as a replacement for the mental task of imagining different possibilities before deciding which faders or pots to adjust. A similar example of how cognitive processes often are offloaded onto physical actions is found in Kirsh and Maglio (1994), who describe how Tetris players rotate the figure on the screen several times before the best fit is found, instead of mentally rotating the figure first to decide on the most efficient way to rotate the figure on the screen. The offloading of cognitive tasks in listening, imagining sounds, mixing music, and so on can be

observed at many levels. When imagining a tight sound, for instance, one may activate motor actions that mirror this metaphor such as squeezing one's hand or biting one's lip. These bodily actions function as aids to the cognitive task because they build on the same *action metaphor*.

I have previously (Walther-Hansen 2014) accounted for the way linguistic action metaphors are observed in the language of sound engineers; expressions such as "pull the sound out," "push it back in the mix," "tuck it in," "squeeze it," "expand it," and "move it out of the way of other sounds" can be seen as traces of underlying cognitive action metaphors that govern how sound qualities are imagined in the mixing process. If a mixing engineer needs to actually make the sound, it is necessary to perform some kind of concrete action on a mixing interface. The interface—here seen as an extension of the cognitive processing—might support the patterns of reasoning that take place internally, or the interface might conflict with, challenge, or provide the basis for changing patterns of cognitive processes. In this way, understanding and reasoning are negotiated through different types of interface as well as negotiated through language when, for instance, discussing a specific sound with a collaborator.

One striking feature of most of today's mainstream digital interfaces for mixing music is their resemblance to analog mixing desks designed more than a half a century ago. The graphical visualization of sound editing on computers, tablets, and smartphones is most often modeled on what I call the SIGNAL FLOW metaphor (Walther-Hansen 2017): The sound enters the desk through wires and runs through an equalizer, auxiliary busses, a panning control, and a dynamic fader before leaving the channel strip at the bottom (thus is it visualized). Having a design that closely resembles the design of earlier technologies, of course, makes the transition from one technology to the next easier and perhaps more intuitive, but it is not necessarily more intuitive for prospective sound engineers who did not grow up with analog technologies.

Although, like me, most university lecturers grew up with analog recording technologies and vinyl recordings, many of the students enrolling in universities today have little experience of an analog mixing desk. Still, it is a strong metaphor when designing new interfaces and software for music production in the digital domain despite opportunities to rethink the design. For this reason, music production courses still spend a lot of time teaching the act of *engineering* (i.e., routing, fixing, improving sound), in which the focus is on the physical manifestation of sound (e.g., sound as waves), as opposed to the act of *designing* sound (i.e., imagining, creating, shaping), in which the focus

is on the quality of the perceived sound realized through the activation of cognitive metaphors.

In order to understand why the SIGNAL FLOW metaphor persists in the field of music production, one must look back at the history of recording technology. The invention of the dynamic fader in the context of music mixing took place in 1959 in Atlantic Studios in New York. Atlantic was one of the first studios with an eight-track Ampex recorder, and the engineer, Tom Dowd, found that it was a tedious task to operate eight tracks at the same time with rotary knobs. The thinking behind the design of the faders is this: Full gain (signal level) is brought up to the faders. To open up the gate (to allow the sound signal to pass through) you push the faders forward/up, and to close the gate you pull the faders down/toward you. This line of thinking makes perfect sense from the point of view of technology (i.e., the idea that sound is *routed through* the mixer). From the point of view of sound design, however, when a music producer might want to squeeze, pull, and push the sound, the mixing desk is counterintuitive—in fact, one would have to *push* the fader forward when *pulling* a sound forward in the mix (see Walther-Hansen 2017).[1]

The SIGNAL FLOW metaphor, learned from technology, is a strong metaphor in sound engineering, and it remains the prime metaphor in this field, although the design does not follow logically from the embodied cognitive capacities that we use to make sense of sound quality. It seems that it remains a strong metaphor only because many engineers have learned to use it through practical interaction with technology, by reading textbooks about sound recording, and so forth. It is fair to speculate that the SIGNAL FLOW metaphor will weaken in the future with a new generation that did not grow up with analog technology. Also, increases in computing power and other technological advances will pave the way for the design of new interfaces that build on other metaphors. The SOUND CONTAINER metaphor proposed in chapter 2 might serve as the basis for such a new design (see also Walther-Hansen 2014, 2016, 2017). This would require the ability to *shape* sound in three-dimensional space, however, and ideally this should involve haptic feedback to reflect any pulling, pushing, or squeezing of sounds in the container. This change would not only allow for more intuitive interaction with sound but also would strengthen some of the cognitive metaphors already reflected in language. Although it is technically possible today to create an interface that allows the user to shape sound and receive haptic feedback from virtual objects in free air, we are still (despite the research mentioned in this book) quite a way from understanding how sound quality is cognitively processed, and, accordingly,

even further from the development of a three-dimensional interface that allows the manipulation of more than a few sound quality characteristics at a time.

Action metaphors are not only important in the process of interacting with sound. They also form part of the listening experience when no physical response is required. This idea is well accounted for in relation to music. Granot and Eitan (2011) performed several experimental studies that connect the classic idea of musical tension (stemming from the organization of tones) with other qualities of sound and music such as loudness and tempo, but studies in auditory tension outside the musical realm are generally lacking. Although the virtual actions that tones and harmonies perform in music are conventionalized in the language of music analysis, in which the tension of a dominant seventh chord is typically released to the tonic, for instance, no such conventions exist in the language we use to describe sound quality.

In developing a model for describing the way recorded sound involves qualities that are cognitively processed as *force* structures, it is worthwhile to revisit Rudolph Arnheim's (1954/1974) account of the perception of works of visual art. According to Arnheim, the composition of a painting can be understood as "an interplay of directed tension. These tensions are not something the observer adds, for reasons of his own, to static images. Rather, these tensions are as inherent in any percept as size, shape, location, or colour. Because they have magnitude and direction, these tensions can be described as psychological 'forces'" (p. 11). As the analog to this, sound engineers often describe sounds in the mix as objects with inherent *force tendencies*. A sound might *cut through* the mix, sounds can *fight for attention*, a mix treated with too much dynamic range compression might sound *squashed*, and some sounds might start to *duck* other sounds. If *heavy* sounds are panned to one side the mix can *fall over*, while other sounds may *stabilize* the mix. In paintings, according to Arnheim, larger objects are typically heavier than small objects and a red object is typically heavier than, for instance, a green or blue object (see the Heavy/Light entry in Chapter 4). When evaluating recorded music, low-level sounds such as bass guitar and kick drum often have a similar status—heavy elements are central to the stability of the mix.

I prefer the term *sound container* to other common ways to describe the spatiality of recorded sound (e.g., sound stage [Moylan 1992] and sound box [Moore, 1993]) because the container concept highlights the perceived functional relation between the content and that in which it is contained. Sounds are not simply located within the container; they are also *controlled* by it. It is

perceived as an enclosure that may constrain sound depending on the metaphorical characteristics of the container and the metaphorical characteristics of the sound. Consider, for instance, the following quotation from producer Tom Elmhirst:

> The Urei [compressor 1] will have been set with a very fast attack and a super-fast release, doing perhaps 10 dB of compression, while the Fairchild [compressor 2] will have had a very slow release. I can't quite explain what this does, but in my head the Urei will *catch* anything that *jumps out*, while the Fairchild will *pick up* the slack and keep a more constant *hold* of the vocal. (Tom Elmhirst, cited in Tingen 2007f, n.p., my italics)

In this quotation four expressions of forceful action are present:

- *Jump out* describes the sounds as forceful objects that *act*, moving from the inside to the outside of the container.
- This movement is counterweighted by compressor 1 (the Urei), which *catches* the sound, preventing it from jumping out.
- A second compressor *picks up* the slack.
- And finally, it keeps a *hold* on the vocal, confining it to a fixed position.

The forces of the vocal sound are restricted by the compressors, which, on one hand, cause the voice to stay in the container and, on the other, keep it in a fixed position within the container.

Although this example describes a succession of events in which the sound engineer responds to the perceived characteristics of the mix by adding dynamic range compression, it is fair to suggest that the experience of tension between sounds in the mix, and between sounds and that in which they are contained, are integral to the perception of, for instance, a piece of recorded music.

Outro

A cup of coffee cannot be warm and cold at the same time. Neither can the cup be both heavy and light. Warm and cold as well as heavy and light are mutually inconsistent qualities of the perceived object. An increasing number of studies shows that the connection between qualities in one domain is retained in another domain. Many cognitive concepts work by *mutual inhibition*. If

one concept is activated in experience, it prevents the other from being activated. It makes sense to say that a dark sound evolves into a bright sound, but the sound cannot be both dark and bright at the same time. Evaluating sound quality is a task in which sensory input is structured by our embodied cognitive capacities—capacities that aid in the organization of thoughts and actions into meaningful categories. Lakoff (2008) describes this as a process aimed at "maximizing the number of overall neural bindings" (p. 24). When concepts are not mutually contradictory but fit the overall cognitive framework, they are easier to process, remember, and respond to.

The argument here is that cognitive processing of sound works best (is most efficient) if it is governed by a system (composed of internal processes and contextual factors) that allows for the greatest possible fit of ideas, actions, linguistic concepts, and so on across the senses. If the layout of an audio interface fits the schematic organization of an imagined sound, then it is easier to realize the sound in practice; if a color or shape on a screen fits the corresponding metaphorical qualities of the sound, the sound is processed faster; if you dim the light while playing a dark sound, you are likely to enhance the experience of darkness, and if you write down the term *warm* on piece of paper while listening to a piece of music, you are more likely to hear the qualities of warmth in the sound.

The belief that some concepts enhance each other across sensory modalities in specific contexts also means that other combinations of stimuli and context may weaken or prevent the activation of specific metaphors. Whereas discourses of sound regulate what one is likely to hear in a recording, they also influence or even determine what one is likely not to hear.

Mutually contradictory concepts are used to distinguish one sound quality preference from another, as we have seen in debates between listeners with a preference for analog sound and those who favor digital media. We may assume that there would be little reason to designate the sound of a CD as cold if it were not for the purpose of distinguishing it from the warmth of the analog recording, and because these metaphors are prevalent in this debate—and become conventionalized over time—they also serve as sources for specific ways of listening. Remember: Analog playback media did not sound warm before digital audio became widespread.

We can, further, make some assumptions about the effect of prior knowledge about (or visual contact with) the playback medium during listening. In the case of music production, I argued that interfaces that fit the mental images with which sound quality is assessed and imagined may enhance cognitive processing because the interface allows cognitive computation to be offloaded onto the environment. When you evaluate the sound quality of

a recording of your favorite track there is a cognitive task to be performed but no physical task. Given the discourse attached to specific technologies, however, knowledge of the playback medium will not only affect your evaluation of the sound quality but will also limit the range of judgments you can readily make about the sound quality (if you are a vinyl aficionado you already know it is warm). Thus, the playback technology (or knowledge about it) can be seen as a physical manifestation of a specific discourse—a discourse that frames the way sound quality is assessed.

PART II

ENCYCLOPEDIA

4

Conceptualizing Sound Quality

An Encyclopedia of Selected Sound Terminology

> The biggest problem in critical listening is finding words to express
> our perceptions and experiences. We hear things in reproduced music
> that are difficult to identify and put into words. A listening vocabulary
> is essential not only to conveying to others what we hear, but also to
> recognizing and understanding our own perceptions. If you can attach
> a descriptive name to a perception, you can more easily recognize that
> perception when you experience it again.
>
> **R. Harley,** *Introductory Guide to High-Performance Audio Systems*

This chapter is built around a list of metaphorical expressions struc-
tured in pairs of opposing concepts—30 concepts and 15 pairs. In many
instances only one of the terms in each pair occurs frequently in natural
language. In these cases, I outline definitions for the opposing term that
follow logically from the metaphorical structure of the more common
term. Each entry discusses related terms, and each term is examined for
its metaphorical use and the discourses underlying sound and music
communities, as described in Part I. The aim is not to present a compre-
hensive list of entries but to provide the reader with examples of how lin-
guistic metaphors make sense and are connected to underlying cognitive
metaphors. These examples should help the reader make sense of not
only the terms in the encyclopedia but also other audio descriptors not
mentioned here.

Various sources were used in the preparation of the encyclopedia,
and the methodology consisted of both software-based corpus linguistic
approaches and human analyses of written texts about sound and music.
A substantial part of my research was based on a specialized corpus
consisting of written texts concerning sound (e.g., music reviews, hi-fi
magazines, and sound engineering literature). This corpus (currently more

Making Sense of Recordings. Mads Walther-Hansen, Oxford University Press (2020). © Oxford University Press.
DOI: 10.1093/oso/9780197533901.001.0001.

than 50 million words) was compiled in order to investigate how metaphors about sound occur in natural language and to ensure that the selection of encyclopedia entries was not based merely on assumptions about which sound descriptors would occur frequently in language. The corpus extends from 1942 to 2017, making it possible to closely examine historical changes in the way sound was conceptualized during this period.[1] Other sources such as Google Ngrams and Etymonline (Harper 2015) were used to examine the development of linguistic metaphors before the mid-nineteenth century. Analyses of the corpus were conducted using concordance software (Wordsmith Tools) to highlight (quantitatively) the frequency and significance of concepts (keyness), to investigate the immediate contextual environment of specific sound descriptors (the co-text), and to examine repeated occurrences of these descriptors across different texts about sound and music (the inter-text). A subsequent manual reading of the sentences deduced in the machine-generated part of each analysis allowed me to assess the material qualitatively in order to further explore specific discourses.

Balance/Unbalance

Balance is one of the most important cognitive concepts in sound production and perception. Musical movement is often conceived of as driven by sonic elements that continually balance and unbalance each other in different forms of tension-and-release patterns (Scruton 1999; Hjortkjær 2011; Granot and Eitan, 2011), and sound production is largely about balancing sounds relative to each other in order to achieve a well-balanced mix (or to deliberately create tension and imbalance as a creative effect).

Metaphor

Balance (from Latin *bilanx,* meaning "a scale with two pans") has been used in a figurative sense since at least the 1570s to mean "a state of equilibrium between parts" (Harper 2015, n.p.). "A well-balanced sound" became a common expression in literature about concert hall acoustics, broadcasting, and music recordings in about the 1940s.

Balance is grounded in basic sensorimotor experiences in our bilaterally symmetrical bodies, for instance, the ability to maintain an upright stable

position when standing still, to continually regain a balanced position from an unbalanced state when walking or running, the experience of a loss of bodily balance when sick, and drinking when you are thirsty to restore bodily balance. These experiences can be extended into the feeling of having (or being exposed to) too much or too little of something relative to some normal sensorimotor state, cultural convention, or aesthetic preference.

Balance in auditory experience is tightly connected to metaphorical force and weight (Walther-Hansen 2016). These forces can be realized in two ways. The first is *twin-pan balance*: In music recordings, balance can be realized as an arrangement of forces distributed relative to an imaginary center axis. Sound engineers, for instance, often think of their mix as a seesaw. If something is panned left it should be counterweighted with something else with a similar weight in the right side of the stereo field in order to keep the mix in balance. Balance, then, is not about absolute symmetry between sound elements (i.e., timbrally similar sounds on both sides of the stereo field) but about the relative distribution of particular qualities of the sound such as its weight. For this reason, heavy sounds such as the kick drum and bass drum tend to keep the mix stable when positioned close to the center position, which functions as the center of gravity (see figure 4.1).

The second way is by *equilibrium balance*, the experienced state of equilibrium in a system. In music production, balancing sound is about finding the right amount of "ingredients" (e.g., heavy sound, light sound, rough sound, and soft sound) to reach an ideal mix of elements in the sound container. It is also related to creating a harmonious arrangement and interaction between the elements (e.g., blending the elements properly with each other). Finally, equilibrium balance is connected to the creation of a balanced functional relation between the sound container and the content in such a way that sounds are contained and constrained in the mix with the right amount of control (e.g., controlling the dynamics with dynamic compression). We are often more aware of balance

Figure 4.1 TWIN-PAN BALANCE schema

Figure 4.2 EQUILIBRIUM schema (adapted from Johnson 1987)

when we experience a loss of equilibrium in a system such as distortion from overloaded signals in a recording. Distortion may, in this case, be realized as an excess of sound in the medium—there is too much sound relative to the size of the sound container, and that causes the forces between the boundaries of the sound container and the content to be in an unbalanced state (see figure 4.2).

Physical Signal

Balance is a bodily activity that is not governed by a specific set of rules. It is often a felt sense of "right" and "wrong" in experience, and the relation between the way in which balance is activated in experience at different points in history and in the physical signal is unclear.

Balance is a cognitive value that applies to every aspect of the evaluation of auditory experience. In the evaluation of recordings, the connection between the physical signal and the notion of balance is closely tied to musical genres and historical conventions. We may, however, point to three overall properties of balanced sound:

Spectral balance concerns the relative amount of bass and treble in a mix. In a well-balanced mix sounds are distributed across the frequency spectrum to give enough room for each sound. An excess of sound in one frequency

band gives rise to spectral imbalance. The notion of weight also plays a significant role. Low-frequency sounds (considered to be heavy) create a proper grounding, and high-frequency sounds make the sound lighter.

Stereo balance relates to the distribution of sounds on the lateral axis. In most recordings made since the early 1970s, heavy sounds such as bass drum and kick drum are located in the center position to prevent the mix from tilting to one side. For this reason, these heavy sounds are also referred to as "anchor points" (Hodgson 2010, p. 165). Weight is, however, not the only influential force in determining balance. The place that the lead voice, for instance, occupies in the mix is usually more important to perception than are the places of other sounds (see Chion and Gorbman's [1999] account of "vococentrism"), and the lead vocal can therefore destabilize the mix if panned hard to one side. Stereo balance, then, is connected to the relative distribution of weight and perceptual value across the lateral dimension.

Dynamic balance In music production, the expression "balancing the sound" most often means adjusting the relative volume between individual tracks to reach a satisfying mix (see Wadhams 1988). If we think of the mix as an organism we can make sense of the act of balancing the dynamics in two ways: (1) it is about finding the right proportion between individual elements for the organism to function properly, and (2) it is about finding the right "amount" of elements relative to the size of the sound container—if there is too much, then the recording is overloaded and distorts.

Discourse

Since the first recordings of music (that could also be played back), the act of balancing sound sources has been an important skill, and balance has been an ideal in the technological striving for higher standards. In the age of mechanical recording (until the mid-1920s), balancing was primarily about finding an appropriate room for recording, positioning the musicians close to the recording horn, and adjusting the needle appropriately in order to prevent it from making the grooves too deep. Later, with the advent of the improved microphone and electrical recording, the act of balancing became a matter of positioning the microphones relative to each sound source. It was with the introduction of the three-track Ampex tape recorder and the improvement of the equalizer in the beginning of the 1950s that balancing became an important part of post-production. The gradual importance of balance as an essential concept in music production is underlined by the fact that the main recording engineer in Abbey Road Studios (EMI Studios at that time) during the 1960s was also known as the balance engineer.

The structural influence of the TWIN-PAN BALANCE schema on listening and music production practices today was formed in the late 1960s and beginning of the 1970s with the gradual establishment of conventions for stereo mixes. Allan Moore and Ruth Dockwray (2010) point to the forming of these conventions in their study of mixes produced between 1966 and 1972. Their survey shows that mixes with vocal, bass, and kick drum centered and other sound sources panned left and right (what they call a *diagonal mix*) became conventional after 1972. In 1966 60 percent of stereo mixes had central sound sources such as vocals and drums panned hard to one side. Six years later these mixes only accounted for 11 percent of the total, whereas 78 percent had a spatial layout with vocals, bass, and drums in center position. It seems, then, that the TWIN-PAN BALANCE schema emerged not as a significant structural principle with the introduction of stereo recording (modern stereophonic technology was invented in the 1930s, but stereo recordings were not mass-produced before the late 1950s) but with the development of multitrack recording (using 16 and 24 tracks) in the early 1970s. What counts as a balanced stereo recording today is perceptually learned from recording studio practices that changed in tandem with new recording and mixing technologies.

During the postwar era, high-fidelity (hi-fi) technologies flourished among hobby engineers (addressed in magazines such as *High Fidelity*, launched in 1951) who experimented with audio components to create audio systems that were as natural-sounding and balanced as possible. Balance is realized as an ideal sound quality, measured against actual (nonmediated) sound. With the spread of ready-made hi-fi systems during the 1960s, balanced sound became a common concept with which to brand the quality of these systems, and it still is today. Table 4.1 contains a summary of the main auditory traits that contrast balanced sound with unbalanced sound.

Table 4.1 Main distinguishing characteristics of balanced and unbalanced sounds

Balanced sound	Unbalanced sound
Is of high quality	Is of low quality
Is undistorted	Is distorted
Has equal lateral distribution of weight	Has unequal lateral distribution of weight
Is of appropriate volume	Has too much or too little volume
Sounds natural	Sounds unnatural
Has an organic sound	Has a dead sound
Is restful	Evinces tension

Big/Small

Whereas it is common to see a description of something having "a *big* sound," people are less likely to refer to something as a *small* sound. The metaphors are, however, often expressed in language with related terms such as a *tiny*, a *huge*, or a *large* sound.

The term *big sound* is for many people connected to the sound of symphony orchestras and big concert halls, and a tiny or small sound is related to the sound of small, softly played, and (perhaps) fragile objects. The terms are also commonly used when assessing music technology (e.g., instruments and playback systems).

Metaphor

Generally, a big sound is something that either fills up the playback environment or fills up the resonant body or sound container in which it resides (figure 4.3).

In Indonesia the descriptors *big* sound and *small* sound correspond to high and low pitches. This makes sense insofar as large objects with a large mass usually produce low pitches, whereas small objects with a small mass usually produce high-pitched sounds. Theo van Leeuwen (1999) writes that high-pitched voices can be used to make our selves small and low-pitched voices to express dominance, and Linda-Ruth Salter (2019) further relates a big sound to other attributes such as mass, big energy and power. For this reason, a big sound is also seen as potentially more "dangerous" than a small sound.

Pedro de Alcantara (2011) qualifies this view further, stating that *big* sound is not related only to the power and size of the sound source: "A big

Figure 4.3 BIG-SMALL schemas

sound, . . .—a sound that is resonant, uniform, and yet elastic in its potential for changes of dynamic and color—requires more than brute force. Rather, it entails the total absence of brute force, and instead the perfect coordination of the musician's entire body, from head to toe; a virtuosity to allow sound to flow out of the instrument" (p. 3). He thus defines *bigness* as a subtle quality of sound that emerges from perceived control of the sound-producing action.

Trevor Wishart points to an overall environmental metaphor that governs the understanding of pitches as high and low but which also points to other attributes of sound quality such as size:

> Any creature which wishes to take to the air, with one or two exceptions, needs to have a small body weight and therefore tends to have a small sound-producing organ and produce high frequency vocalisations. Conversely, any large and heavy creature is essentially confined to the surface of the earth and at the same time will possess a correspondingly larger sound-producing organ and a consequently deeper voice. Crudely speaking, airborne creatures have high voices and earthbound creatures low voices. (1996, 192)

Although *big* does sometimes correspond to *fat*, there are usually differences between these expressions (see also the Fat/Thin entry). First, a fat sound is usually something compact (i.e., a fat sound is not necessarily big). Second, a fat sound is usually produced by artificial means; that is, the technology involved is clearly perceivable. It is common, for instance, to talk about a fat- but not a big-sounding synthesizer, and symphony orchestras might sound big, but their sound is seldom fat.

Physical Signal

Loudness is probably the single most influential parameter for perceived auditory size. Loud sound is often big, and soft sound is often small. The connection between loudness and bigness is only activated, however, when the sound-producing sources are capable of producing a certain mass of sound. For instance, overloading a sound system not made for producing loud volume does not lead to auditory bigness. Similarly, the amplified sound of a single triangle is unlikely to produce the experience of a big sound. The number of sound sources has a big influence on the experience of the sound's bigness or smallness. A symphony orchestra or a choir, for

instance, has a big sound. A big sound source, or perhaps more precisely, a big sound source capable of using the entire corpus to produce the sound, may also produce a big sound (e.g., a singer using mainly the throat to sing as opposed to a singer using stomach muscles as well). For similar reasons, a big sound usually has much more low-frequency content than does a small or tiny sound.

Discourse

Historically, a big sound has been associated with the sound of big concert halls and especially symphony orchestra music. The development of new music and sound technologies—especially from the mid-twentieth century onward—came to influence the size of recorded sounds in different ways. Susan Schmidt Horning (2012) describes how, in the 1960s, the "big hall sound" gave way "to a different kind of big sound more dependent on artificial reverberation, multiple layers of instruments and numerous effects" (p. 31). A big sound, then, became a more complex phenomenon that was no longer associated simply with the size of actual rooms but included various sound qualities that all added to the sound's bigness.

Sometimes big sound was described as an effect of the specific arrangement and instrumentation. Chorus, violins, and instruments such as Hammond organs and saxophones often were associated with a big sound. Later, bigness was credited to the specific recording technique, and from the late 1950s, the bigness of the sound was articulated in advertisements for many rock and roll records, for instance, in the title of Johnny and the Hurricane's album from 1960 "The Big Sound of Johnny and the Hurricanes."

A big sound is a great sound, and it has always been understood as a sign of good quality. From the mid-1960s, with the improved volume of amplifiers, large playback systems were marketed as big-sounding (see the example in figure 4.4)

Still today, a big sound is associated with the sound of a large sound system. Such systems are said to create a big sound, a massive sound, large volume, and a big sound pressure. One challenging goal of loudspeaker designers is to push as much bigness into small cabinet loudspeakers as possible, and today's portable Bluetooth speakers are often appreciated for their ability to produce a bigger sound than one would expect from their physical size. Table 4.2 presents a summary of the main auditory traits that contrast a big sound with a small one.

Figure 4.4 Advertisement for the Stereo-Round sound system promising that "Stereo-Round gives you music with the big sound" (*Billboard*, April 3, 1965, p. 61)

Table 4.2 Main distinguishing characteristics of big and small sounds

Big sound	Small sound
Reverberates in a large room	Reverberates in a small room
Is produced by a large playback system	Is produced by a small playback system
Is a loud sound	Is a soft sound
Is low pitched	Is high pitched
Sounds dominant	Sounds submissive
Sounds fat	Sounds thin

Clean/Dirty

Clean and *dirty* sound metaphors are sometimes transferred directly from the domain of physical objects. In this mapping, noise and other unwanted artefacts are dirt, and what is underneath is clean sound. But more often, *clean* and *dirty* are comprehended relative to other metaphorical understandings, as in their use in the domain of morals and ethics—and it is in relation to the latter domain that dirty sound (something that transgresses the clean) is often cognitively organized, for example, in descriptions of musical genres.

Metaphor

Dirtiness and *cleanliness* refer to a quality of physical places or objects. In about 1530 (Harper 2015, n.p.) the terms came to be used metaphorically in the sense of being morally clean or dirty). Related to this use, *dirtiness* often is evaluated negatively and *clean* often is evaluated positively—dirt is something to be avoided or removed in order to obtain cleanliness.

Dirty in the sense of moral transgression affects the way sound is evaluated. A dirty sound may, for instance, describe the misbehavior or misuse of a sound technology (distorted amplifiers) or some transgressive use of the human voice.

Sound engineers often refer to the process of "cleaning up the track." In order to make sense of this action, one must think of the track in terms of a physical place (that needs cleaning) and the sound artefacts that are removed in terms of dirt. Accordingly, to clean up the track is to get rid of noise (e.g., clicks and pops) and other unwanted artefacts.

There is a close link between clean sound (as a metaphor for the sound quality) and the sound produced by a clean playback medium. When vinyl records are played, physical dirt causes the needle to produce unwanted artefacts and to diminish the sound quality. For this reason, specialized cleaning systems are available that allow audiophiles to obtain a cleaner sound (see figure 4.5)

Physical Signal

Clean often means "free of distortion." In film sound recording, *clean sound* also refers to a recording without audible interference from the surroundings, often difficult to achieve when recording on location.

Figure 4.5 Advertisement for the Clean Sound Record Cleaning System, targeted at hi-fi and record retailers (*Billboard*, October 16, 1976, p. 45)

In the domain of audio recording and hi-fi manufacturing, a clean sound is connected to the perfection of the signal circuit. A clean sound can be achieved with high-quality components—good cables, high-quality amplification, proper impedance matching between parts, and so on. Also, a sine wave is sometimes referred to as a clean signal, whereas a square wave (introduction of harmonics) is referred to as a dirty signal (Singmin 2000).

Cleaning of a track can be achieved with noise filters. The Dolby noise reduction system, invented in 1965, was the most common system for increasing the signal-to-noise ratio and create cleaner sound on tape decks in the 1970s. Modern digital noise filters usually create a noise profile of the sound and then filter the noise out (using fine-masked, multiband noise gates). Digital noise reduction found in much audio software, such as the algorithm introduced in Cool Edit Pro (1.0) in 1997, effectively reduces hum and hiss, but it also introduces less pleasant artefacts such as high-frequency sizzle and dropouts.

Discourse

In the 1920s, *dirty* described the tone of some hot jazz musicians. Later it was used to describe the raspy tone produced by saxophones (Brackett 2003). The term was commonly associated with the sound of overdriven tube guitar amplifiers, a sound many artists explored during the 1950s and a sound that became characteristic of rock in the 1960s. The Gibson Maestro FZ-1 Fuzztone was one of the first customized effect units to create this sound; the effect was popularized with Keith Richard's use of the unit on the Rolling Stones' "I Can't Get No Satisfaction" (1965).

Table 4.3 Main distinguishing characteristics of clean and dirty sounds

Clean sound	Dirty sound
Is non-distorted	Is distorted
Sounds sterile (unexciting)	Does not sound sterile (exciting)
Is noise-free	Is noisy
Is unoffensive	Is morally unclean/offensive

Dirty has been applied in the sense of morally unclean (beneath the bourgeois moral) to describe musical genres such as a rock and blues. But there are also examples of classical compositions being deemed as dirty (or too dirty); this was, for instance, one of the responses to Stravinsky's ballet *Petrushka* in 1911 (see White 1966).

Clean sound as a new ideal in sound reproduction emerged, in part, as a result of changing marketing strategies in the record business in the beginning of the 1960s. High fidelity—in the sense of being true to life—had figured as a sound quality ideal for several decades, and with the rapid development of new sound formats (such as stereo recordings, now widely available), there was a need for a discursive change in the way products were presented (Bartmanski and Woodward 2015).

Also, with the introduction of new and improved recording technologies (in the sense of a greater signal-to-noise ratio), dirty sound became an aesthetic quality to be used actively in record production. Punk rock, for instance, emerged as a countermovement against an aesthetic ideal that, among other things, hailed still greater excellence in recording technology.

In discussions of the quality of digital audio technology, the notion of clean sound also had a double status. In the beginning of the 1980s, the recording industry highlighted the clean sound of digital technologies, in which the dirt is removed and only the pure and clean sound is left. Audiophiles, on the other hand, criticized digital audio for being too clean, sterile, or simply unexciting. Table 4.3 presents a summary of the main auditory traits that contrast clean sound with dirty sound.

Clear/Blurred

Clear/blurred and the related pair *distinct/muddy* are terms adopted from vision. The concepts qualify the way objects are presented to the perceiver and the perceiver's ability to see something. This ability is usually connected

to the characteristics of the medium through which the object is presented. Some media are perceived as being transparent, resulting in a distinct and clearly perceivable object, whereas other media appear opaque, resulting in the object's having a blurred or muddy appearance.

Metaphor

A clear sound is perceived as different from the background and distinguishable from other things. The character and quality of the sound make it dissimilar from other sounds heard simultaneously in such a way that the sound draws attention to itself. A blurred or indistinct sound blends in with the background. It may be obscured by other sounds, or it may have an indistinct start and ending that makes its temporal appearance blurry. For the same reason, *blurry* is linked to uncertainty. A blurry sound leaves the perceiver with an experience of doubt and ambiguity. A clear sound, on the other hand, provides clarity and certainty.

A transparent audio medium allows for a clear and distinct sound. *Clear* and *transparent*, as metaphors mapped from vision, designate the audio medium's ability to mediate the sound without coloring the original sound source. If the medium is opaque, the perceiver cannot hear the original sound source clearly, and the sound source might then appear muddy or blurred.

Physical Signal

Many sound engineers will define a blurred sound as a sound dominated by frequencies in the area below about 400 Hz. Bob Katz (2002, p. 43) is more specific; he defines *muddiness* as an excess of energy in the area below about 250Hz. It is also a quality of sound waves travelling through solid material. Imagine listening to music from an adjacent room in your house. The sound above about 250 or 300 Hz (depending on the material) is typically attenuated, and this will cause the sound to seem blurred and difficult to locate precisely.

A muddy sound may also result from an excess of information (i.e., an overload of the sound container), which may be caused, for instance, by too many tracks or instrument groups playing at the same time or by the use of excessive dynamic range compression. Adding reverb may also cause the sound to appear muddy. Heavy reverberation on a vocal track, for instance, may cause the

lyrics to become unintelligible, especially if the pre-delay is too short and the wet signal blends too much with the dry signal.

A clear and distinct sound, on the other hand, is easily localizable, and it does not blend too much with other sound. For the same reason, the terms *clear* and *blurred* are often connected to perceived distance. A clear sound is close, whereas a muddy sound is further away.

Discourse

Clear and *blurred* are often used as quality markers for mediated sound. As described in preceding chapters, the norms and expectations for "good sound" change in tandem with aesthetic ideals and the cognitive metaphors that emerge from experiences with different media. This change is also described by Ragnhild Brøvig-Hanssen (2016) in a study of the relation between transparent and opaque forms of mediation. Citing Auner (2000), she writes that 'when technology is replaced the limitations comes to the fore; the veil of transparency is lifted and we are forced to start listening to the accent as all the repressed characteristics of the old emerge with shocking clarity' (Auner 2000). The vinyl noise of the analog medium has, for instance, become more detectable since the advent of the digital medium's silence. Thus, what is initially perceived as opaque mediation can later be taken as transparent. For instance, when vocalists first started to use the microphone as an instrument, experimenting with different techniques and developing new singing styles (such as the intimate singing style called crooning), listeners saw the microphone-staged voice as opaque mediation, whereas today it has become a defining trait of the voice and is thus (more or less) transparent (p. 163).

Table 4.4 contains a summary of the main auditory traits that contrast a clear sound with a blurred sound.

Table 4.4 Main distinguishing characteristics of clear and blurred sounds

Clear sound	Blurred sound
Is localizable	Is non-localizable
Has a balanced frequency content	Is dominated by low frequencies
Is definable	Is undefinable
Is the sound of transparent mediation	Is the sound of opaque mediation
Is the sound of an appropriate amount of auditory information	Is the sound of too much auditory information

Dark/Bright

Dark and *bright* are common terms for describing sound quality, and the correlation between perceived brightness and attributes of sound has been well documented (see, e.g., Marks 1982, 1989). The metaphorical meaning of *dark* and *bright* may take a number of forms. The three most common metaphorical entailments are "dark is unknown—bright is known," "dark is unhappiness—bright is happiness," and "dark is evil—bright is good" (see Deignan 2005; Kövecses 2002). In the domain of auditory perception these meanings give rise to a conceptual blend of these different meanings.

Metaphor

The original meaning of *dark* (from Old English) is "absence of light." In the sixteenth century, *dark* and *bright* primarily described qualities of colors. These color categories are often mapped from the visual domain to other modalities such as taste, smell, and audition (e.g., dark aromas, dark flavors, and dark sound [see Paradis 2015]).

Dark and *bright* are also commonly mapped to the target domain of emotion, where dark is unhappiness and bright is happiness. These mappings are further structured by a VERTICALITY schema (an up-down continuum), in which unhappiness is down, while happiness is up and dark is down, while bright is up. Löffler (2017), in a study of the dependence between the BIG-SMALL schema and colors, further suggests that bright objects are smaller than dark objects (see figure 4.6).

Dark sounds are often seen as mysterious, secret, or not fully exposed, in contrast to bright sounds, which are more exposed. This mapping seems to be retained from the domain of vision, where what is hidden in the dark is unknown and what is brought to light is known.

Wapnick (1980) found that perceived brightness and darkness were perceptually related to microtonal features of sound. Dark sound was related to perceived flatness, and bright sound was related to perceived sharpness.

Physical Signal

Dark and *bright* are usually associated with the frequency content of the sound and the perceived acoustic environment. Cutting the harmonics (high frequencies) has been reported to make the sound darker (Bartlett and Bartlett 2009),

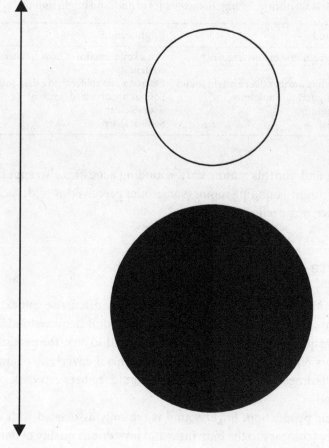

Figure 4.6 DARK-BRIGHT schema. BRIGHT IS UP, DARK IS DOWN, DARK IS BIG, BRIGHT IS SMALL.

and brightness is usually caused by greater emphasis on the high frequencies. To be a little more specific, experimental research shows that perceived brightness is strongly correlated to what is known as the "spectral centroid" (calculated as the weighted mean of the frequency spectrum—see Schubert, Wolfe, and Tarnopolsky 2004). Accordingly, a high-pitched sound is not necessarily brighter than a low-pitched sound, as is the common assumption in research concerning how pitch triggers colors (see, e.g., Simner 2013).

Dark and *bright* are also common terms in the evaluation of room acoustics. A dark-sounding room is one that creates a lot of high-frequency roll-off. Carpets or other materials that absorb high frequencies on the surfaces can cause listeners to evaluate the sound as dark. There is a causal link between the acoustics of living room areas and soft furniture, carpets, and other soft

Table 4.5 Main distinguishing characteristics of dark and bright sounds

Dark sound	Bright sound
Has a large amount of low-frequency content	Has a large amount of high-frequency content
Often sounds warmer than a bright sound	Often sounds colder than a dark sound
Sounds mysterious (unknown)	Sounds unconcealed (known)
Sounds muddy	Sounds clear
Sounds flat	Sounds sharp

materials, and, for this reason, dark-sounding acoustics also appear warmer than very bright-sounding rooms (sometimes perceived as cold) such as those with harder, more reflective surfaces.

Discourse

The semantic value of *dark* and *bright* is tied to the discursive context. In heavy metal genres, for instance, the darkness of the sound is understood in relation to emotive qualities (sadness, dark thoughts, and so on). The persistent use of dark colors on graphical artwork for heavy metal covers, merchandise, and so on underlines the cross-modal correspondence between dark colors and *dark* sound.

In music production, *bright* sound is typically associated with definition and clarity (contrary to the blurriness and mysterious quality of *dark* sound), and some sound engineering professionals complain that today's recordings are becoming overtly *bright*. Table 4.5 presents a summary of the main auditory traits that contrast *dark* sound with *bright* sound.

Fat/Thin

Fat, thick, and *thin* are common metaphors in music production and are widely used when evaluating the sound of synthesizers. *Fat* or *thick* is correlated with *big, beefy, full, rich,* or *deep* and often is evaluated positively. Producers of house music, for instance, often strive for a fat sound with a full and deep low end. Some old analog synthesizers are characterized by a fat sound, and some digital synthesizers are designed specifically to emulate this effect (figure 4.7); a thin sound is one of the characteristics of low-bit digital sound synthesis.

Figure 4.7 Phat Bass VST plugin

Metaphor

Thick is usually defined by very specific properties. The concept *thin*, on the other hand, is defined by a set of more general features (Kirchin 2013). Theodore Gracyk (1996) distinguished between a musical work concept with a thick ontological status and work concepts with a thin ontological status. A recording, for instance, is a thicker ontological realization of music than a sheet of music is. It is possible to perform the sheet music in many ways, with different instruments, and still retain the identity of the music. A recorded piece of music is characterized by a specific arrangement of sounds. If the sound changes, the music recording loses its specific identity. Thus, the recording is ontologically thick, while the sheet music is ontologically thin.

In a similar manner, we may say that thick sound is characterized by many layers of defining properties. You add something to a sound to make it thicker and take something out to make it thinner. Multilayered sounds are generally thicker than a single track or a single instrument. Low-bit recordings or recordings only using a narrow bandwidth are usually considered thin.

Musical harmonies may also have different thicknesses. A chord may acquire a thinner sound if some pitches in the harmony are omitted. For

instance, it is common to omit the fifth in a seventh chord to create a thinner-sounding chord.

Some languages use thickness as a metaphorical realization of pitch. In Farsi, Turkish, and Zapotec high pitches are thin and low pitches are thick (Shayan, Ozturk, and Sicoli 2011; Casasanto 2017).

Physical Signal

A fat sound often has an accentuated low end—beneath approximately 250 Hz. Too much accentuation in this area can cause a boomy sound (usually a more negative term).

According to Paul Théberge, "A 'fat' sound . . . can be defined as a sound that is the result of [the] 'spreading out' or expansion of the audio signal in one or more domains: temporal, spatial, amplitude, and/or frequency"; mainly it is used to describe "the sound of several instruments of the same type playing together" (1997, p. 209). Although a big sound is one of the hallmarks of symphony orchestra music, popular music recordings use different kinds of effects to a larger extent to fatten up the sound. This can be achieved by using, for instance chorus, flanger, and delay effects. Similar principles are mentioned in Bartlett and Bartlett's (2009, p. 126) five tips for making a guitar sound fatter:

- Send the guitar signal through a digital delay set to 20 to 30 msec. Pan guitar left, delay right. Adjust levels for nearly equal loudness from each speaker. (Watch out for phase cancellations in mono.)
- Send the guitar signal through a pitch-shifter, set for about 10 cents of pitch bending. Pan guitar left, pitch-shifted guitar right. (A cent is 1/100 of an equal-temperament semitone. There are 100 cents in a half-tone or semitone interval of pitch.)
- Record two guitarists playing identical parts, and pan them left and right. This works great for rhythm-guitar parts in heavy metal.
- Double the guitar. Have the player re-record the same part on an unused track while listening to the original part. Pan the original part left and pan the new part right.
- Add stereo reverb or stereo chorus.

Some engineers also point to dynamic range compression as a way to fatten up the sound (see, e.g., JJ Puig, cited in Tingen 2007c). Older tube compressors or preamps, in particular, are known to produce this quality.

Table 4.6 Main distinguishing characteristics of fat and thin sounds

Fat sound	Thin sound
Is layered instruments of the same kind	Is the sound of a single instrument
Is the sound of tube compression	Is the sound of uncompressed sound
Is the sound of analog synthesizers	Is the sound of (low bit) digital synthesizers

Discourse

Tara Rodgers (2010) explains how the tendency for oscillators to drift out of tune was seen as a problem for early synthesizer manufacturers. This drifting, however,

> would eventually be embraced by musicians as a desirable feature rather than a problem to be corrected. Moog synthesizers in the 1970s were commonly described by musicians and electronics enthusiasts as having a particularly "fat" sound precisely because its oscillators "tended to drift" in relation to each other, which generated variable sonic texture over time. (p. 83)

In an essay about the obese American rapper Big Pun (1971–2000), Joan Gross (2005) explores the metaphorical extension of the term *fat* in hip-hop culture. According to Gross, the fat sound as an auditory aesthetic ideal extended into other areas of the culture, and rappers often proudly proclaim their size in the names they adopt: Notorious B.I.G., Heavy D, Fat Joe, Large Professor, the Fat Boys, Pudge, Tha Phat Bastard, and Big Pun. They refer to themselves in songs as "overweight lover," "Big Daddy," "heavyweight Bronx Champ," and even "big belly babalu boogaloo big boy" (p. 70). . . . "in hip hop, fatness is celebrated as a positive sign of power and attraction" (p. 76). Table 4.6 provides a summary of the main auditory traits that contrast fat sound with thin sound.

Full/Hollow

A *hollow* sound may be associated with the sound of an empty resonant space, for instance, what you hear if you drum on an empty plastic box. There is no direct relation between a *hollow* sound and a hollow sound source, however. A drum is hollow, but the sound of a drum may be characterized as full. *Hollow* is often evaluated negatively, whereas *full* is evaluated positively.

Metaphor

A hollow object lacks content. Likewise, a hollow person lacks substance and character. In similar ways one may refer to a hollow life—a life characterized by emptiness, lack of meaning, or lack of values.

Sometimes the terms *full* and *big* are interchangeable in descriptions of sound, but there are usually differences between a full and a big sound, as well as between a small and a hollow sound. These differences can be explained in terms of the relation between mass and size. A balloon, for instance, may be big but lacks mass and is characterized by an empty space inside. The balloon, then, is not small but hollow. *Full* defines something whole and complete. The object is there in its entirety, and what you perceive on the shell is continued in the inside.

Full is used as an expression of quality across several senses. A full taste, for instance, is one that activates all (or most) taste buds, a full smell is one whose odor pervades your olfactory sense, and a full view is a one where you can see everything (you need to see).

Physical Signal

The auditory characteristics of a square wave produced by a synth-oscillator are often characterized as hollow. This is caused by the arrangement of harmonics and the fact that a square wave contains only odd harmonics (see Russ 2008). The missing second and fourth harmonic are pivotal in creating the distinctive hollow sound. A full sound, on the other hand, is one with an overtone-rich timbre. Thus, in order to capture a full sound from acoustic instruments on a recording, engineers seek to capture the entirety of the instrument's sound.

For similar reasons, phase cancellation may also cause a hollow sound (see Winer 2012). A flanging effect, for instance, which emerges when one of two identical signals is delayed, has a hollow sound. This process, whereby two identical signals have phase differences, is also known as comb filtering due to the appearance of the notches caused by the destructive interference of the two signals (see figure 4.8).

Discourse

The expression "a full sound" was more prevalent in the 1950s than it is today. Often, music reviewers would refer to the full sound of the symphony orchestra, the organ, or the chorus. The reason might be that recording

Figure 4.8 Comb filter

Table 4.7 Main distinguishing characteristics of full and hollow sounds

Full sound	Hollow sound
Is massive and rich	Is lacking content/mass
Is produced by a sawtooth wave	Is produced by a square wave
Includes all harmonics	Lacks harmonics
Has no phase cancellation	Has phase cancellation
Sounds detailed	Sounds less detailed
Is of good quality	Is of bad quality

technology was under rapid development at the time, and the quality of different recordings varied a lot. A full sound was therefore an indication of the recording's excellence or worth compared to other recordings. A lack of ability to capture the details and richness of sound sources is less of an issue today. Still, sound engineers will often talk about ways to make the sound fuller, for instance, by bringing out the overtones. Table 4.7 presents a summary of the main auditory traits that contrast a full sound with a hollow sound.

Heavy/Light

In the domain of music, *heavy* is largely synonymous with the genre of heavy metal. *Heavy metal* emerged as a niche term in the 1960s. *Heavy* is also a common term in characterization of specific features of sound quality, and it is in this latter case that *heavy* is sometimes contrasted with *light*.

Metaphor

In Elias Longley's (1853) *American Manual of Phonography*,[2] light or whispered sounds are represented by a light stroke on the paper, and a heavy sound

is represented by a heavy stroke. This usage points to an early acknowledgment of the cross-modal mapping between physical gesture and perceived auditory features.

Heavy and *light* are terms for physical weight. Heavy objects weigh more than light objects and they, therefore, exhibit different force tendencies (see Talmy 1988). Heavy things, for instance, are more powerful than light objects. A heavy object thrown against something will transmit more force to the object it hits. Moreover, heavy objects do not move easily. It takes great effort to move heavy objects because the forces of gravity result in a tendency for heavy objects to stay at rest in a specific position. Light objects, on the other hand, are much more inclined to give in to external forces. This idea was used by Rudolph Arnheim (1954/1974) to make sense of the spatial distribution of objects in a picture. In order to balance a picture the artist must apply an equal distribution of visual weight across the frame. Similarly, the balance of the sound container is influenced by the distribution of auditory weight (see also the entry for Balance/Unbalance).

Physical Signal

The shape of the frequency band provides the most direct link to experiences of heavy and light sound. Sounds with a lot of low-frequency content are considered heavy, and sounds with a lot of high-frequency content are considered light. Other parameters, however, such as reverberation and spatial distribution, also have an effect on perceived heaviness. Since the experience of heaviness is often linked with weighty and firmly grounded objects, sounds floating in reverberation or sounds that appear at a distance often appear less grounded and lighter. High volume, a flattened dynamic envelope, and distorted amplification are also considered important parameters of perceived heaviness.

Discourse

> When I mix something that's heavy, it's dry, it's in your face, it's wide, it's deep.
>
> **Mark Alan Miller**

"Heavy metal" became broadly used as a genre category during the 1970s. In a review in *Billboard* (1974a, p. 46) it is described as an overused term, and

in a later issue in the same year the term is still in quotation marks (*Billboard* 1974b, 58). Toward the end of the 1970s it became a more firmly established genre category. Robert Walser argues that the term was transferred from the domain of chemistry and became publicly known through discussions of heavy metal poisoning in the media (Walser 1993).

Perception of heaviness is source-dependent. A distorted guitar is more likely to be considered heavy than an oboe, regardless of the frequency content of the two sounds. Berger and Fales (2005) have shown that heavy metal fans find this music to be much heavier today than it was a few decades ago. By comparing spectrograms from excerpts by 1970s heavy metal bands such as Judas Priest and Black Sabbath with excerpts from 1990 sampled from bands such as Grave and Winters Bane, Berger and Fales found that increased heaviness was correlated with, among other things, more high-frequency energy, more noise, and a flatter dynamic envelope. But the authors also recognized that these findings were distinctive for the specific cultural context (that of metalheads), in which noise and long sustain have come to signify "extreme power and intense expression" (Walser 1993, p. 59). The correlation between perceived heaviness and overdriven amplifiers further connects heaviness to loudness (see Weinstein 2000).

Older examples of discourses about music show that *heavy* and *light* are not always contrasted with each other. In ancient Greek, (*barys*, meaning "heavy," was contrasted with *oxys*, meaning "sharp" (Barker 1989, p. 69) to designate pitch height. This could indicate that the ancient Greeks were more concerned with other auditory qualities of pitch than its height and depth. For centuries, the term *light music* has described music that is easy to listen to. Adorno (1932/2002), for instance, contrasted light music (music without any great substance) with serious music. In Adorno's fight against the so-called culture industry, light music became a symbol of the passivity of the masses, who apparently preferred the consumption of light music to that of serious music. Table 4.8 presents a summary of the main auditory traits that contrast heavy sound with light sound.

Table 4.8 Main distinguishing characteristics of heavy and light sounds

Heavy sound	Light sound
Has a large amount of low-frequency content	Has a large amount of high-frequency content
Is often darker than a light sound	Is often brighter than a heavy sound
Is often powerful and energetic	Is often weak and calm
Is loud and overdriven	Is soft and clean
Has a flattened dynamic envelope	Has dynamic variation

Open/Closed

The concept of *openness* is connected to the notion of accessibility. Making something open to view (see Johnson 1987, p. 36) means making something available to the perceiver. That which is *closed* or bounded, on the other hand, remains unavailable or hidden to the perceiver. An open sound reveals itself. It is easily graspable, and it seems to propagate freely in air from the source to the perceiver without obstacles.

Metaphor

Open is often used in a metaphorical sense to describe human characteristics; the term *open-minded*, for instance, is recorded from 1828 (Harper 2015, n.p.). Similarly, we connect *open* and *closed* with the way in which sounds are afforded to us.

Sound engineers often speak of open sounds and closed sounds. Stanley R. Alten (2011) links the openness of a sound with being airy, transparent, natural, or detailed (p. 463), while openness for Bruce and Jenny Bartlett is described in terms of gentleness and "letting the instrument 'breathe'" (Bartlett and Bartlett 2009, p. 42). These producers appear to connect openness with sounds that are not restricted. Open sounds are allowed space to be transmitted in their acoustic environment and are brought to the listener in a transparent manner (figure 4.9).

Dynamic range compression can have an effect on a sound's perceived openness or closedness. In some cases, a sound engineer may bring a compressor into the signal chain to make certain sounds more open, whereas in other cases compression helps keep a sound more closed. Quiet sounds are usually brought out when the overall mix is compressed, and loud sounds that

Figure 4.9 Examples of OPEN-CLOSED schemas. *Left:* The container is closed and the content concealed. *Right:* The content can move freely and is accessible from outside the container.

stick out too much can be kept in place inside the mix. In this way the perceived openness or closedness of a sound is often realized as an effect of the relation between the container (the overall mix) and the content (the individual sounds; see Walther-Hansen 2014).

Physical Signal

Open/closed may not actually be a metaphor but, rather, something grounded in the acoustics of real-life situations, for instance, (1) when we hear a sound emanating from within a closed container (a physical container) or (2) when we hear a sound that reaches our ears without any obstruction between the source and the listener. In the first example, some part of the high frequencies is absorbed (filtered out) by the boundaries of the container, and in the second example we hear the sound unaffected by any barrier. For the same reason, the experience of open sounds is related to accessibility and closed sounds to exclusion.

The phrase "open up the sound" can be understood either on the level of individual sounds or on the level of the track as a whole. Cutting out high frequencies will often create a closed sound, whereas more openness is often achieved by boosting the sound at around 10 kHz. A sound that opens up can be processed with a low-pass filter that sweeps upward.

Discourse

The terms *open sound* and *closed sound* originated in the field of phonetics to designate the vowel sound; for instance, they are used to distinguish between the *a* in *father* and the *a* in *wall*. Building on this use, music reviewers have applied the terms to characterize the voice of singers, for instance, in stating how much or little they open the mouth to allow the sound to come out. The terms have also described the design and sound of audio playback technology. Writing about recording techniques for guitarists, Jon Chappell (1999) compares open-back speakers and cabinets to close-back speakers and cabinets, which push the sound through the front, resulting in a punchy and compressed sound: "Open back [speakers] allow the sound (mostly bass frequencies) to escape through the back of the amp, which results in a more 'open' sound preferred by blues guitarists" (p. 40).

The voicing of harmonies may also influence the perception of a sound's openness. Jazz pianists, for instance, distinguish between close voicings, in

Table 4.9 Main distinguishing characteristics of open and closed sounds

Open sound	Closed sound
Is the sound of transparent mediation	Is the sound of opague mediation
Sounds accessible, unobstructed	Sounds inaccessible, obstructed
Sounds airy	Sounds dull
Sounds alive	Sounds dead
Has a boosted high end	Has a high-cut
Is produced with open voicings	Is produced with close voicings

which pitches are placed as close together as possible, and open voicings, which allow vertical space between individual sounds (see Stefanuk 2001, p. 13). A close-voiced chord typically sounds more constrained and less open than an open-voiced chord. Table 4.9 contains a summary of the main auditory traits that contrast an open sound with a closed sound.

Organic/Synthetic

When trying to understand the contrast between *organic* and *synthetic* sound it is worthwhile considering the first public demonstration of a robot voice in 1931. Until that time, the voice was a sound that could be made solely by the human body. In that sense, the voice was the archetype of an organic sound. The robot voice, on the other hand is, in the words of its inventor, Rudolf Pfenninger, "tones from out of nowhere" (see Levyn 2006). Its arrival was in many ways a milestone for the idea of the synthetic sound—a sound that emulates a voice but is virtually "sourceless" because it originated from hand-drawn graphic representations on a piece of paper and, as a result, highlights the contrast to organically produced sounds.

Metaphor

The term *organic* (in the meaning "serving as an organ") emerged in the sixteenth century (Harper 2015, n.p.), and it has been used in a variety of contexts to describe events, objects, ideas, and so on organized as or behaving as living beings. Sound engineers often conceptualize the mix as an organism and the sounds within the mix as animate objects. They may, for instance, talk about techniques to "make the compressor *breathe*" (Owsinski 1999, p. 55),

ways to make the sound "come *alive*" (Ed Seay, cited in ibid., p. 166), or about overusing compression so that the sounds are "squeezed to *death*" (George Massenburg, cited in ibid., p. 50, all italics mine). Such expressions governed by the overall ontological metaphor SOUND AS ANIMATE BEINGS.

The term *synthetic*, for "put together or constructed," has been used with reference to products (e.g., textiles) since at least the mid-nineteenth century (Harper 2015, n.p.). Usually synthetic products are made artificially with some kind of chemical synthesis. The expression "synthetic sound," then, makes sense owing to a conceptual mapping between the domain of artificially constructed things and the domain of sound.

Physical Signal

One may say that synthetic sound equals electronically generated sound and organic sound equals sounds produced by acoustic instruments or the human body. Such definitions, however, only consider the source of the sound as opposed to its qualities, that is, how synthetic or organic it is. Yet the broad and general nature of the terms makes it difficult to point in any simple way to the physical attributes that define these qualities in a sound without pointing to the source or the technology involved in processing the sound. The synthetic qualities of a sound often stem from technologies, whereas the organic part often emerges from natural (non-technological) sources (or the technology's ability to imitate natural sources faithfully). A vocoder, for instance, changes the organic and natural qualities of the human voice into something synthetic, artificial, unreal.

Although *synthetic* is derived from the word *synthesis*, there is sometimes a discrepancy between the way *synthetic* is used as sound quality descriptor and the actual production of the sound. A pure tone, with a sine wave form (which first emerged with the invention of the electronic oscillator), for instance, sounds synthetic to most people although there is no sound synthesis involved. It is, however, by definition, artificial because no natural source can produce this sound.

Discourse

In his book about sound synthesis Martin Russ (2008) states that "synthetic implies something that is similar to, but inferior to 'the real thing'" (p. 31).

Synthetic, then, is understood as something that is unnatural trying to emulate the natural but that cannot do so perfectly. Pinch and Trocco (2002) write that Don Buchla (who co-invented the modular synthesizer with Robert Moog) was reluctant to call his invention a synthesizer because it suggested that the device imitated or emulated other instruments.

The concept *synthetic* and the value of this term have changed along with technological innovations and the gradual acceptance of analog synthesizers. Although many rock fans in the 1970s found synthesizers inhuman, numerous electro-pop bands in the 1980s found that the qualities of the analog synthesizer stood out from those of the inferior digital synthesizers that entered the market in the same period (see Goodwin 1988). Also, the advent in the 1990s of digital instruments (e.g., VST plugins) that emulated the analog synthesizers promoted their acceptance as more real than their digital counterparts. Still, the term *synthetic* often is interpreted negatively when used in the context of sound quality evaluation, whether the evaluated sound is in fact synthetic or not.

In other cases, *synthetic* is used in the sense of "otherworldly" or simply "strange-sounding." In a 1967 *Billboard* review of the album *No Way Out* by the American psychedelic garage rock band the Chocolate Watchband, the reviewer describes the band's sound as follows: "The synthetic sound of the Chocolate Watch Band will excite the frantic fans of psychedelic, electronic rock . . . the haunting irregularity of the beat, lapsing into dizzy electronic wails[,] will strike today's market square in the psyche" (*Billboard* 1967, p. 34).

On a more general level *synthetic* and *organic* are seen as distinguishing between the aesthetics of popular music production and classical music production (in the broadest sense). Whereas producers of traditional classical music often aim for transparency and try to capture the natural sound of the instruments, the synthetic sounds of technologies are often integral to popular music recordings. Table 4.10 presents a summary of the main auditory traits that contrast an organic sound with a synthetic one.

Table 4.10 Main distinguishing characteristics of organic and synthetic sounds

Organic sound	Synthetic sound
Sounds natural	Souds unnatural, artificial
Is the sound of the real	Is the sound of the unreal
Sounds human, animal or nature-like	Is the sound of technology
Is the sound of a transparent recording	Is the sound of a opaque recording
Sounds unprocessed	Sounds processed

Rough/Smooth

Smooth is one of the sound quality terms that appears in different contexts as a positive descriptor of the quality of mixes, recording technologies, instruments, and so on. *Rough*, on the other hand, may be interpreted negatively or positively. *Smooth* often correlates with *fresh, warm, round, detailed, coherent*, and *well-balanced*, whereas *rough* often correlates with terms such as *hard* and *edgy*.

Metaphor

Rough and *smooth* are tactile sensations. *Rough* can refer to the coarse surface quality of physical objects. A rough (uneven) surface is counter to a smooth (even) surface. A smooth movement across something is one that proceeds without interruptions. The metaphorical use of the terms dates back centuries; now they are used in a variety of contexts. *Rough* is often used in the sense of an unfinished condition. The expression "a rough draft" is recorded from 1690 (Harper 2015, n.p.). To record a rough sound is to record a sound that does not yet have the right shape, is unstructured, is not detailed enough, or is simply imperfect. A rough version of a track, then, serves as the basis for further treatment. One can also say that the sound is rough as a consequence of the sound-producing apparatus's being in bad condition. A smooth sound, on the other hand, has the right proportions. Nothing sticks out or appears to be interrupting the temporal unfolding of the sound.

Physical Signal

An early attempt to define the concept of auditory roughness was presented by the physicist Hermann von Helmholtz (1875/2011). Helmholtz found that auditory roughness increases with the number of interference beats between tones (up to about 33 beats, after that the roughness diminishes as the number of beats increases). Sounds with a low number of interference beats, so-called simple tones such as the sound of a tuning fork, are, according to Helmholtz, free of all roughness.

Bigand and colleagues (1996) found a correlation between the tension value of chords and the perceived roughness of the sound. Generally, the greater the perceived dissonance, the greater the perceived tension

and roughness. In a more recent book about sound recording, Bartlett and Bartlett (2009) define a smooth sound as a sound in which no particular frequency band is emphasized. It does not, therefore, stand out too much.

Discourse

Musicians producing a smooth sound seem to do so effortlessly. Smooth sounds have few abrupt and strong gestures that direct our attention to the sound-producing event or that makes the sound stick out. Accordingly, a smooth sound transition is one that changes in a non-abrupt way from one sound quality to another.

A rough-sounding voice is common among male singers and it is often characterized by "hoarseness, harshness, rasp, [and] grit" (Mulder and van Leeuwen 2019, p. 477).In *Psychology of Music,* Tan, Pfordresher, and Harré (2013) describe a rough voice as having a "quality [that] occurs when the vocal folds are not held close enough, and some of the air stream gets through. A typical cause of this problem is from calluses ('nodes') that form on the vocal folds, often after years of abuse (singing too loud)" (p. 217). Rough sound is thus connected to abuse of the voice. Similarly, a rough sound may be connected to the malfunctioning (intentional or unintentional) of audio technology. A demo recording, for instance, will often have a rough sound quality.

Smoothness, on the other hand is correlated with naturalness. Louis Armstrong not withstanding, many jazz and soul singers are well known for a soft and smooth sound, whereas rough-sounding voices are often found among hard rock singers. Table 4.11 presents a summary of the main auditory traits that contrast smooth sound with rough sound.

Table 4.11 Main distinguishing characteristics of smooth and rough sounds

Smooth sound	Rough sound
Is a perfect or nearly perfect sound	Is an unfinished sound
Has an even spectromorphology	Has an irregular spectromorphology
Sounds natural and pleasant	Sounds harsh and rough
Is the sound of a soft and effortless gesture	Is the sound of a hard and strenuous gesture
Is a sustained sound	Is an abrupt sound
Is the sound of a consonant harmony	Is the sound of a dissonant harmony

Soft/Hard

In phonetics, the terms *hard* and *soft* have for centuries been used to distinguish between different sounds in speech. One can, for instance, distinguish between the hard or soft sound of some consonants when used in a specific context, for instance, the hard sounds of *c* and *g* in *cars* and *go* as opposed to the soft sounds of *c* and *g* in *citrus* and *gentle*.

Hard and *soft* emerged in the vocabulary of sound recordists and music reviewers during the mid-twentieth century. *Hard* and *soft* point to two very distinct aesthetic ideals, and, most often, hard sounds and soft sounds serve very different functions in music production. Hard sounds are usually used for lead instruments, and soft sounds usually function as pads blending into the background. Ambient music, for instance, is dominated by soft sounds, and heavy metal is mostly dominated by hard sounds.

Metaphor

Soft and *hard* are tactile sensations. *Hard* is the quality of solid and firm material, and *soft* is the quality of material that gives in to pressure. In an acoustic sense, the sound made by resonance in hard material, such as metal, can be characterized as hard or sharp.

The meanings of *hard* sound and *soft* sound are related to the physical effort and energy put into the sound-producing gesture. Hitting the drums hard, pulling the guitar string hard, or pressing the bow hard against the violin string is likely to produce the sensation of a hard sound. Soft sound, on the contrary, is often produced when less force is put into the gesture.

Along the same lines, a hard sound is often something that takes an effort to listen to (is hard to listen to), and some might even be repulsed by it. For this reason, *hard* often is interpreted negatively. Soft sound, on the other hand, is easy to listen to—it takes little effort from the listener—and therefore provides a comfortable atmosphere.

To make sense of the way the concepts *hard* and *soft* are transferred from the domain of physical objects to the domain of recorded sound, we may, as an example, consider some of the metaphorical entailments of the CONTAINER schema (see chapter 2). There is a metaphorical connection between the hardness of physical objects of a high density (and possibly a high impedance coefficient) and sound containers with a high concentration of sound content relative to their size. Heavily compressed tracks (high-density, compact

tracks), for instance, are often perceived as being harder-sounding than tracks with a low density of sounds.

Physical Signal

Hard sounds usually have a defined beginning and ending. Film sound designers, for instance, talk about hard sound effects when describing abrupt sounds from the environment such as doors slamming and gunshots. The duration of the attack is an important factor. Hard sounds have a short, emphasized attack. Making the attack longer usually makes a sound softer. A soft sound often has low volume, and a hard sound often has a higher volume. Softer-sounding tracks usually have more dynamic variation and a greater spatial perspective than harder tracks. Many sound engineers say that dynamic microphones produce a harder sound than, for instance, condenser microphones (see, e.g., Parsons and Colbeck 2014). A hard sound also occurs as an effect of clipping in the digital domain; hard clipping while overdriving an analog system will usually produce a relatively smooth transition from the clean to the dirty sound, resulting in a softer sound.

Perceived hardness and softness are also connected to overall amplitude. Quiet sounds are usually softer than sounds with a high amplitude. In general, a hard sound tends to cut through the mix, but a soft sound tends to blend in.

The perceived surface material of the acoustic environment also influences the sound's hardness. Hard sound-transmitting material (high-impedance material) such as tiling on bathroom walls, creates a hard-sounding acoustic (hard reflections) in which the sound bounces off the walls. Soft reflections in material with lower impedance, on the other hand, are more diffused and blend in more with the direct sound.

Discourse

Hard and *soft* have been used to designate musical genres since at least the 1960s. The expressions "soft rock" and "hard rock" began to emerge in the beginning of the 1960s, and by the end of the decade they were common subcategories of rock (soft rock being roughly equivalent to pop-rock). Artists such as Carole King and the Carpenters were among the mainstream soft rock acts. The expression "hard rock" changed its meaning as listeners slowly became accustomed to the new sounds of rock such as the distorted electrical guitar. In the mid-1960s tracks such as the Beatles' "She Loves You" were considered

Table 4.12 Main distinguishing characteristics of soft and hard sounds

Soft sound	Hard sound
Is a low-level sound	Is a loud sound
Has a large spatial perspective	Has little spatial perspective
Takes little effort to listen to	Takes much effort to listen to
Reverberates in a room with low-impedance surfaces	Reverberates in a room with high-impedance surfaces
Sounds organic	Sounds metallic
Is an acoustic sound	Is a synthetic sound
Is produced with little physical power	Is produced with great physical power
Has a long attack	Has a short attack
Is the sound of analog overdrive	Is the sound of digital clipping

hard rock by some. Toward the end of the century other parameters (e.g., aggressive drum and vocal sounds) became characteristic of a number of hard rock bands such as Led Zeppelin and the Who. Also, the development of amplifiers (still louder output signals), distortion devices, and more energetic playing styles contributed to an increasing debate about harder sounds. As Robert Walser (1993) notes, "Drummers of the late 1960s hit their drums very hard, resulting in a sound that was not only louder but heavier, more emphatic" (p. 10). Table 4.12 presents a summary of the main auditory traits that contrast soft sound with hard sound.

Tight/Loose

Tight and *loose* are usually used in connection with performative qualities of music. A tight performance has little timing slack, and it is precise in terms of pitch and dynamic accuracy. A loose performance, on the other hand, is characterized by greater variation and lesser overall accuracy. Similarly, *tight* and *loose* as descriptors of sound quality are understood in terms of precision and accuracy; for instance, a clearly defined start and ending, accurate variation in amplitude, and accurate spatial placement denote a tight sound.

Metaphor

Something that is kept tight is kept under strict control. When you loosen your grip on something you let go of your control of the object. Tight-miking of sound sources, for instance, usually involves close-miking in order to pick up as much detail as possible and to minimize leakage from other sources.

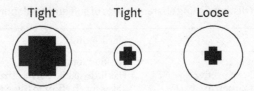

Tight Tight Loose

Figure 4.10 TIGHT-LOOSE schemas

Moving the microphone further away will result in a less controlled, more airy, and loose sound.

In order for an object to be under control, it requires some kind of enclosed space. *Tight* and *loose* can be understood in terms of relations of control between container and content. These relations can be divided into a *geometrical relation* between object and container and a *functional relation* between object and container. The geometrical relation is defined in terms shapes and sizes. Small objects in big spaces are loose, whereas big objects in small places are tight (see figure 4.10); many things in a small space are tight, yet a few things in a large space are loose. The functional relation between object and space is defined by the specific characteristics of the object and the space. The constraints provided by different sorts of containers are associated with varying degrees of location control, and the specific characteristic of the contained object requires different degrees of location control. Animate things, for instance, require different forms of enclosure to keep in place than do inanimate things (a bowl provides suitable location control for an apple but not for a fly).

This is comparable to the difference between the recording of a sine wave and a vocal track. A dry sine wave can never be loose, it is by definition tight. Vocals (typically more animate than a sine wave), on the other hand, can sit more or less tightly in the mix depending on the vocal performance, the recording, the treatment of the sound in post-production, and so on.

Physical Signal

The expressions "tight sound" and "loose sound" are often heard in connection with drums. A tight sound usually has little ambience (it does not float in the air), is precise in terms of timing and pitch, and usually has a clearly defined attack. A loose sound, on the contrary, lacks precise timing and pitch. This is not, however, necessarily a negative attribute; it may be a valuable aspect of the sound depending on the context.

Dynamic range compression may have an influence on the perceived tightness or looseness of a sound. A heavily compressed sound is usually tighter than an uncompressed sound that has greater dynamic variation.

According to some sound engineering textbooks, equalization can influence a sound's tightness or looseness. Tim Dittmar, for instance, writes that "a loose sound would lack the harder mid-mid frequency area" (2011, p. 34).

Discourse

In a 1966 *Billboard* interview, vice president Howard Kester of the California-based radio station KEZY described the station's sound as "a tight sound" (Tiegel 1966, p. 40). This sound was, according to Kester, created with the use of a mild reverberation effect.

The continuous struggle for a cleaner and more controlled sound was also one of the major reasons for the dissemination of multitrack tape recorders in the major recording studios. Mark Cunningham (1996) describes how the introduction of 16- and 24-track tape machines in the early 1970s resulted in instruments' having a much more detailed and tight sound. This shift in sound quality was especially noticeable with regard to the clarity and tightness of drum tracks because it was now possible to close-mike individual drums on separate tracks.

Some argue that a tight sound is a mark of professionalism. It signals that the performer and the producers have the sound under control. Similarly, a loudspeaker may be praised for a distinct tight sound that signals good-quality components. Although looseness is not necessarily a mark of amateurism, it signifies a more relaxed attitude that favors aesthetics and freer forms of expression that are less preoccupied with control and perfectionism. Such aesthetic ideals are prevalent in, for instance, punk rock and free jazz. Table 4.13 presents a summary of the main auditory traits that contrast a tight sound with a loose sound.

Table 4.13 Main distinguishing characteristics of tight and loose sounds

Tight sound	Loose sound
Has no or little reverberation	Is a reverberant sound
Is close miked (no leakage)	Is miked from a distance (leakage)
Has perfect timing and pitch	Has imperfect timing and pitch
Sounds controlled	Sounds uncontrolled
Has a clearly defined start and ending	Has a blurry start and ending
Has a clearly defined location	Is loosely located

Warm/Cold

The title of an article in the *New York Times*, "That Warm Sound of Old in a Cold, Compressed World" (Furchgott 2007), neatly points to one of the key discourses surrounding sound quality in the age of digital audio technology. *Warmth* is reminiscent of past audio technologies. It is seen as an original and authentic attribute of sound that does not emerge naturally in digital sound representation. The emulation of warmth is, therefore, one of the key sound characteristics noted in marketing recording technologies and playback systems, and sound engineers often make a great effort to achieve warmth in their mixes and masters. Still, warmth remains one of the most mysterious and magical characteristics of recorded sound.

Metaphor

In its literal meaning, *warmth* is mainly a tactile sensation activated in our interaction with the environment (warm air, liquid, and solid objects). A warm temperature does not frame a fixed temperature span, but it usually designates a comfortable temperature (a suitable amount of heat) for the human body.

Warmth maps on to several other domains such as emotion, auditory perception, and color perception (e.g., a warm red, orange, or yellow). Since about the fifteenth century, *warm* has been used in reference to social inclusion and feelings, as in the expressions "a warm welcome," "a warm atmosphere" or "warm feelings" as opposed to the coldness of social exclusion. Presumably the relation between a warm temperature and warm feelings is embodied in early childhood when the baby feels the warmth of caregivers. Some experimental studies have shown that social exclusion literally feels cold (Zhong and Leonardelli 2008) and that warm temperatures increase feelings of interpersonal warmth (Williams and Bargh 2008).

The expression "warm sound" appeared in the nineteenth century. The relation between warm temperatures, warm feelings, and warm sounds is in many ways quite direct. Warm sounds provide a pleasant atmosphere. The manner in which it surrounds us is one of inclusion rather than exclusion, that is, our body resonates with the sound as opposed to being repelled by it. For this reason it makes sense to speak about "the warm sound of the voice," as in *Billboard*'s review of Johnny Nash's releases "As Time Goes By" and "The Voice of Love": "Two beautiful sides by the talented chanter. He has a sincere, warm sound on each, and these could be his springboard to big chart disks" (*Billboard* 1959, p. 48). Similarly, Dickie "Bird" Newland was described

as follows: "Newland has a soft, warm sound and he shows it off tenderly on this pleasant rock ballad" (*Billboard* 1960, p. 48). Expressions such as these highlight the connection between warm sound and something natural and organic, heartfelt, and truthful.

Physical Signal

Although the experience of warmth is contingent on context (historical, cultural, genre discourses, and so on), some physical attributes of sound are reported to have an effect on the its warmth. In music recordings warmth may emerge from the use of specific technologies, from specific editing actions, from the performer (e.g., the voice), or from the recording room.

At least since the late nineteenth century, attempts have been made to define warmth in sound. The acoustician Eugene H. Kelly (1898), for instance, defined warm sound as that "in which the fundamental and harmonics are evenly balanced in form, volume and density, while the higher harmonic is greatly reduced in all its proportion." Cold sound, on the other hand, is that "in which the fundamental is forced sufficiently to nearly drown out the harmonics" (p. 33). In Kelly's definition, the opposition between *warm* and *cold* in the source domain (temperature) is retained in the target domain (sound). In newer definitions this opposition is usually weaker or nonexistent. For instance, many sound engineering scholars find that boosting the low-to-mid frequency range adds warmth to sound, but coldness is not necessarily achieved by cutting these same frequencies. Roy Izhaki (2008) argues that a boost in the area between 100 and 600Hz is essential for adding warmth to the sound, and Bob Katz (2002) adds that a low-to-mid boost should be supplemented by a cut in the region of 3-6 kHz. The acoustics of a room are considered warm if the frequencies below 250Hz have a longer reverb time than higher frequencies (Finelli 2002; Gregersen 2011). Cann (2007) argues that a warm sound typically has a slow attack and a slow release, and several authors point to the introduction of harmonic distortion (typically caused by tape saturation) as an important factor in creating a warm sound (e.g., Bartlett and Bartlett 2009; Savage 2014).

Discourse

The meaning of *warmth* has changed in parallel with technological changes. Digitization has led to a longing for the sounds of the pre-digitized era, which

allegedly were warmer than those of the digital era. Although it is no longer a real challenge to eliminate noise and capture a wide frequency spectrum with digital technology, warmth is increasingly used as a quality marker for new equipment. Everything from microphones to preamps, A/D converters, FX units, and cables are today marketed for their warm sound. Likewise, audiophiles tend to praise their favorite hi-fi equipment and playback media for their warm sound. This concept is often implemented in the visual design of the technology as well, for instance, by replicating the looks of audio apparatus from the 1950s or 1960s.

Warmth is something real and uncorrupted by modern computer technology; it is the soul—the realness of something that really existed—and, in this sense, modern digital technology can never come to produce true warmth but can only emulate it. Analog technologies (e.g., analog tape, tube compressors, tube preamps, and valve microphones) are considered to have had warmth from the outset, whereas digital is typically considered a cold (or even dead) medium that must be brought to life by adding emulations of analog warmth. Several software manufacturers have designed units with the specific aim of adding warmth to the sound (see Viers 2011). The PSP MicroWarmer (figure 4.11) is one such unit. According to the company's description, it "combines rich, warm analog processing with a straightforward user interface."[3] Also, the design of the VST plugin points to past analog technologies and thus evokes the warm glow of nostalgia.

The notion of warm sound is interwoven with notions of authenticity. We may, for instance, consider how, in the era of the digitization of sound, we saw a reappropriation of the analog as something more real than the digital (see Goodwin 1988; Théberge 1997). Analog synthesizers, for example, considered by many in the 1980s to be lifeless and artificial (the word *synthesis* itself suggests an emulation of something else), were widely recognized in the late 1990s for the distinctive organic and warm sound they produced in comparison to the digitally emulated versions, and still are today.

We can relate this discourse to some broader cultural and historical traits. In modern society, with its use of the World Wide Web, network culture, and digitization, a great deal of social interaction takes place over the Internet. Critics of this movement point to the coldness of this form of communication, which is based on the lack of (actual) human bodies present at the time and virtual place of the interaction. In the modern network society (see Castells [2002] for a detailed discussion), humans are represented by digits that

Figure 4.11 Vintage PSP MicroWarmer

transfer messages (visual and auditory) between participants. In a parallel to the discourse of cold and warm forms of social interaction, and fostered by pessimism concerning modern technology, many audiophiles characterize CDs and streamed files as cold-sounding and inferior to the warmth of vinyl, which has a much longer history than do the CD and streaming formats. The combination of needle and groove has its roots in the very invention of music recording; it is considered "original." The act of putting on a vinyl disc, gently removing dust from its surface, and placing the needle in the groove is for many audiophiles a part of what makes vinyl a warm medium (see Bartmanski and Woodward 2015). The act of downloading files from the Internet, however, is often considered much more sterile and cold than flipping through physical media in a record store (see Katz 2010, pp. 191–192), further pointing to the way contextual actions related to music consumption have an influence on the evaluation of sound quality. Table 4.14 provides a summary of the main auditory traits that contrast warm sound with cold sound.

Table 4.14 Main distinguishing characteristics of warm and cold sounds

Warm sound	Cold sound
Is an analog sound	Is a digital sound
Has slightly boosted low-mid frequencies	Has (too) much high frequency content
Has a focus on the low harmonics	Has a focus on the fundamental
Is reminiscent of the past	Is the sound of the future
Is related to analog media	Is related to audio files
Sounds smeared or slightly distorted	Sounds clean or sterile
Sounds organic and natural	Sounds artificial
Provides an atmosphere of inclusion	Provides an atmosphere of exclusion

Wet/Dry

Wet and *dry* are two of the most conventional sound quality terms in music production, to the point where perceived wetness almost equals the perceived "amount" of reverb or delay effect added to a recording. Perceived wetness and dryness have also come to characterize genres and mixing conventions specific to certain decades. Popular music of the 1980s, for instance, is identified by its particularly wet mixes, and many of today's post-rock bands rely heavily on wet effects in the creation of their distinctive sound.

Metaphor

Wet (from old English wæt) refers to the liquid or moist quality of substances. Wetness and dryness are qualities that are perceived through the tactile senses. These qualities can be both attributes of physical objects and attributes of our spatial environment such as wet air and dry air.

The concept has its meaning from our bodily experience of being wet, from the most extreme example of being immersed in water to being wet only in part. Wetness is an immersive quality.

In audio evaluation *wetness* usually refers to reverberation. After heavy treatment with reverberation one can say that the sound is "floating in effects" or is "drenched in reverb" (Dittmar 2011, p. 36). When a sound is made wet it changes its appearance, its spatial being, and often its perceived location. Wet sounds are less firmly anchored in the sound container. Sometimes the sound source appears to be floating and thus is difficult to locate at a certain point in space.

Physical Signal

Recorded sounds are commonly described in terms of humidity. In the recording studio, making a sound wetter is essentially understood as the process of applying a spatial effect to it (Wadhams 1988; Brackett 2003). Sometimes, *wet sound* simply refers to the effected (processed) part of the signal. The dry sound (the original sound) is the sound without effects.

A dry sound is usually recorded in an acoustically dead space in order to ensure that the microphone only picks up the sound of the instrument (without the reflections)—the direct sound. This allows the engineer to separate the source (the dry signal) from the spatial environment (the wet signal). It is then possible to blend the dry sound with wet effects and to process the dry signal and the wet signal in different ways (e.g., by placing them in different positions within the sound container). This specific blend has an effect on the perceived acoustic environment and the front-to-back placement of sound sources. Dry sounds are usually experienced as being more upfront, while wet sounds add distance to the sound.

Discourse

Generally, *wet* is a short way to describe the sound of liquids such as that made by water when walking through puddles, the sound of rain, or the sound of body liquids (e.g., saliva). More metaphorical meanings became common in descriptions of music recordings during the 1960s and 1970s. In a 1979 review, for instance, a digital recording of the London Symphony Orchestra is described in these terms: "This is orchestral sound so wet and unfocused that the instrumental groups appear to be swimming all over the aural field. Many listeners appreciate this sort of souped-up production" (Penchansky and Traiman 1979, 50).

Wet sounds (echo effects and other kinds of spatial treatment in post-production) became common elements in the recording studio the beginning of the 1950s. Echo chambers had been in use in broadcasting since the 1930s, and artificial reverberation was used as a gimmick in several recordings. An overly wet sound was generally seen as a deficit in the 1930s, and the Jukebox Operators of America allegedly complained to record companies about the quality of recordings played in spaces that were very reverberant because these recordings sounded awful when played back on the company's jukeboxes.[4]

Table 4.15 Main distinguishing characteristics of wet and dry sounds

Wet sound	Dry sound
Is a sound with spatial effects	Is a sound without spatial effects
Is the sound of liquids	Is the sound of crispy objects
Is a reverberant sound	Is a non-reverberant sound
Is floating in space	Is in a steady-state
Reverberates in a lively space	Reverberates in a dead space
Is often difficult to localize	Is easily localizable

Bill Putnam is recognized as the first engineer to make a number one hit containing artificial reverberation in 1947 with the Harmonicats' "Peg o' My Heart" (see Doyle 2005). The slapback echo effect on Elvis Presley's voice, engineered by Sam Philips in Sun Studios in 1953, is another early and famous example of the gradual increase in the wetness of mixes in the mid-twentieth century. And during the 1950s most of the major studios installed echo chambers (if they did not already have them). This led to a physical distinction between the direct sound and the reverberant sound in recording that was reflected in language, for instance, the ability to blend the dry sound with the wet sound. Table 4.15 presents a summary of the main auditory traits that contrast wet sound with dry sound.

Notes

Introduction

1. Throughout the book I use capital letters to clearly distinguish cognitive metaphors (functioning in the background of our cognitive system) from linguistic metaphors (explicitly stated).
2. In his most recent book Zbikowski (2017) has shifted his focus to a form of musical semiotics, and he shows how musical signs often "stand for" dynamic processes through what he calls *analogical reference*. He is thus concerned with symbolic interaction between musical structures and structural features of the external world.
3. The school bells only appear on the album version of "Get Together."
4. In side chain compression the amount of compression is controlled by an input (the side chain) other than the main input. The effect is often found in dance tracks in which bass, synthesizer, or vocal sounds are sometimes attenuated using a kick drum as side chain. This technique creates a perceptual effect known as *ducking*.
5. I am indebted to Paul Tingen and his excellent interviews with some of the world's top music producers published in Sound on Sound Magazine's "Inside Track" series. I cite some of these interviews frequently throughout the book.
6. Virtual studio technology is the most popular type of software interface for integrating software effects and instruments with software audio editors. It was launched by Steinberg in 1996.

Chapter 1

1. *What Hi-Fi?*, Vinyl vs. CD? https://www.whathifi.com/forum/turntables-and-lps/vinyl-vs-cd. Accessed April 30, 2018.
2. See Wheeler (1987) for more on how metaphors contribute to reality construction.
3. Invention of the Phonograph. https://www.youtube.com/watch?v=qGJR2DZBfF0. Accessed May 25, 2018.
4. See Francis Rumseys's (2008) study of the various conceptions of fidelity and the relationship (or lack of relationship) between fidelity and listening preferences.
5. See Barsalou and Wiemer-Hastings (2005) for more on the cognitive processing involved in situating abstract concepts.
6. See Guberman (2011), who argues that the transition to a post-fidelity era starts in the late 1990s.
7. Steve Hoffman's Music Forum. http://forums.stevehoffman.tv/threads/cassette-vs-cd.197844/. Accessed April 15, 2018.

Chapter 3

1. Some broadcast corporations (e.g., the BBC) previously used reversed faders on some of their mixing desks. This fader layout was not, however, an attempt to challenge the SIGNAL FLOW metaphor. Allegedly the reason was to prevent the speaker from accidentally increasing the volume if he hit the faders with his notebook. Instead of increasing the sound level to the maximum, hitting the faders would shut the sound off.

Chapter 4

1. See Walther-Hansen (2016) for a previous study of sound quality metaphors that uses a reduced version of this corpus.
2. Not to be confused with Eisenberg's (2005) use of the term *phonography*.
3. See the Vintage PSP MicroWarmer Plugin at http://www.pspaudioware.com/plugins/dynamic_processors/psp_vintagewarmer2/. Accessed July 24, 2017.
4. See the discussion at http://forums.stevehoffman.tv/threads/echo-reverb-history-in-recorded-music.210399/. Accessed May 6, 2018.

References

Adeli, M. J. Rouat, and S. Molotschnikoff. 2014. Audiovisual Correspondence Between Musical Timbre and Visual Shapes. *Frontiers in Human Neuroscience* 8, article 352: 1–11.

Adorno, T. (1932) 2002. On the Social Situation of Music. In *Theodor W. Adorno: Essays on Music*, introduction, commentary, and notes by R. Leppert, 391–436. Berkeley: University of California Press.

Alcantara, P. de. 2011. *Integrated Practice: Coordination, Rhythm, and Sound.* Oxford: Oxford University Press.

Alten, S. R. 2011. *Audio in Media.* Boston: Wadsworth.

Antle, A. N., M. Droumeva, G. Corness. 2008. Playing with The Sound Maker: Do Embodied Metaphors Help Childrenn Learn?. Proceedings of the 7th International Conference on Interaction Design and Children, June, 178–185.

Arnheim, R. (1954) 1974. *Art and Visual Perception.* Berkeley: University of California Press.

Auner, J. 2000. Making Old Machines Speak: Images of Technology in Recent Music. *Echo* 2 (2). www.echo.ucla.edu/Volume2-Issue2/auner/aunerframe.html. Accessed August 6, 2018.

Bakker, S., A. N. Antle, and E. van den Hoven. 2009. Identifying Embodied Metaphors in Children's Sound-Action Mappings. Proceedings of the 8th International Conference on Interaction Design and Children, June, 140–149.

Barker, A. 1989. *Greek Musical Writings: Harmonic and Acoustic Theory.* Cambridge: Cambridge University Press.

Barr, P., R. Biddle, and J. Noble. 2002. A Taxonomy of User-Interface Metaphors. Proceedings of the SIGCHI-NZ Symposium on Computer-Human Interaction, July 11–12, Hamilton, New Zealand, 25–30.

Barsalou, L. W., and K. Wiemer-Hastings. 2005. Situating Abstract Concepts. In *Grounding Cognition: The Role of Perception and Action in Memory, Language, and Thought*, edited by D. Pecher and R. Zwaan, 129–163. New York: Cambridge University Press.

Bartlett, B., and J. Bartlett. 2009. *Practical Recording Techniques: The Step-by-Step Approach to Professional Audio Recording.* Focal Press.

Bartmanski, D., and I. Woodward. 2015. *Vinyl: The Analogue Record in the Digital Age.* Bloomsbury.

Bech, S., and N. Zacharov. 2006. *Perceptual Audio Evaluation: Theory, Method and Application.* Chichester, West Sussex: Wiley.

Beilock, S. L. 2009. Grounding Cognition in Action: Expertise, Comprehension, and Judgment. *Progress in Brain Research* 174: 3–11.

Belkin, K., R. Martin, S. E. Kamp, and A. N. Gilbert. 1997. Auditory Pitch as Perceptual Analogue to Odor Quality. *American Psychological Society* 8 (4): 340–342.

Berger, H. M., and C. Fales. 2005. "Heaviness" in the Perception of Heavy Metal Guitar Timbres: The Match of Perceptual and Acoustic Features over Time. In *Wired for Sound: Engineering and Technologies in Sonic Cultures*, edited by P. D. Greene and T. Porcello, 181–197. Middletown, CT: Wesleyan University Press.

Bessman, J. 1998. E Street's Tallent Makes a Vintage-Sound Studio His Gig. *Billboard.* May 2, 40.

Bigand, E., R. Parncutt, and F. Lerdahl. 1996. Perception of Musical Tension in Short Chord Sequences: The Influence of Harmonic Function, Sensory Dissonance, Horizontal Motion, and Training. *Perception & Psychophysics* 58 (1): 125–141.

Billboard. 1959. Johnny Nash–"As Time Goes By" and "The Voice of Love". February 23, 48.

Billboard. 1960. Dickie "Bird" Newland. April 11, 48.

Billboard. 1967. Chocolate Watch Band. November 18, 35.

Billboard. 1973. Petula Clark–Now. January 13, 55.

Billboard. 1974a. Nazareth–Ramplant. July 13, 46.

Billboard. 1974b. Steppenwolf–Straigh Shootin' Woman. August 17, 58.

Blesser, B., and L.-R. Salter. 2007. *Spaces Speak, Are You Listening? Experiencing Aural Architecture*. Cambridge, MA: MIT Press.

Boem, A. 2013. Sculpton: A Malleable Tangible Object for Musical Expression. Proceedings of the 7th International Conference on Tangible, Embedded and Embodied Interaction, February 10–13, Barcelona, Spain.

Brackett, D. 2003. Dry Sound. In *Continuum Encyclopedia of Popular Music of the World*. Vol. 2, *Performance and Production*, edited by J. Shepherd and D. Horn, 647. London: Continuum.

Brackett, D. 2003. Wet Sound. In *Continuum Encyclopedia of Popular Music of the World*. Vol. 2, *Performance and Production*, edited by J. Shepherd and D. Horn, 647. London: Continuum.

Bremner, A. J., S. Caparos, J. Davidoff, J. de Fockert, K. J. Linnell, and C. Spence. 2013. "Bouba" and "Kiki" in Namibia? A Remote Culture Make Similar Shape-Sound Matches, but Different Shape-Taste Matches to Westeners. *Cognition* 126: 165–172.

Brøvig-Hanssen, R. 2016. Opaque Mediation: The Cut-and-Paste Groove in DJ Food's "Break." In *Musical Rhythm in the Age of Digital Reproduction*, edited by A. Danielsen, 159–176. London: Routledge.

Brower, C. 2000. A Cognitive Theory of Musical Meaning. *Journal of Music Theory* 44 (2): 323–379.

Budd, M. 2003. Musical Movement and Aesthetic Metaphors. *British Journal of Aesthetics* 43 (3): 209–223.

Burgess, R. J. 2013. *The Art of Music Production: The Theory and Practice*. Oxford: Oxford University Press.

Cann, S. 2007. *How to Make a Noise: A Comprehensive Guide to Synthesizer Programming*. New Malden, UK: Coombe Hill Publishing.

Casasanto, D. 2017. The Hierarchical Structure of Mental Metaphors. In *Metaphor: Embodied Cognition and Discourse*, edited by B. Hampe, 46–61. Cambridge: Cambridge University Press.

Castells, E. 2002. *The Internet Galaxy: Reflections in the Internet, Business, and Society*. Oxford: Oxford University Press.

Chappell, J. 1999. *The Recording Guitarist: A Guide for Home and Studio*. Milwaukee, WI: Hal Leonard.

Chion, M. 1994. *Audio-Vision: Sound on Screen*. New York: Columbia University Press.

Chion, M. 2002. *Guide to Sound Objects*. http://www.ears.dmu.ac.uk/spip.php?page=articleEars&id_article=3597. Accessed May 14, 2017.

Chion, M., and C. Gorbman. 1999. *The Voice in Cinema*. New York: Columbia University Press.

Clark, A., and D. J. Chalmers. 2010. The Extended Mind. In *The Extended Mind*, edited by R. Menary, 27–42. Cambridge, MA: MIT Press.

Clarke, E. F. 2005. *Ways of Listening: An Ecological Approach to the Perception of Musical Meaning*. New York: Oxford University Press.

Cooke, A. 1953. Interview with Les Paul and Mary Ford on *Omnibus*, October 23. https://www.youtube.com/watch?v=VCEmAgak9V8. Accessed May 10, 2018.

Corey, J. 2010. *Audio Production and Critical Listening: Technical Ear Training*. Amsterdam: Focal Press.

Cuming, T. 1828. Observations on the Peripneumonia of Children. In *The Medico-chirurgical Review and Journal of Medical Science* 13: 67–72.

Cunningham, M. 1996. *Good Vibrations: A History of Recording Production*. Chessington, Surrey: Castle Communications.

Cytowic, R. E., and D. M. Eagleman. 2009. *Wednesday Is Indigo Blue: Discovering the Brain of Synesthesia*. Cambridge, MA: MIT Press.

Deignan, A. 2005. *Metaphor and Corpus Linguistics*. Amsterdam: John Benjamins Publishing Company.

Dittmar, T. A. 2011. *Audio Engineering 101: A Beginner's Guide to Music Production*. New York: Focal Press.

Dockwray, R., and A. F. Moore. 2010. Configuring the Sound-Box, 1965–1972. *Popular Music* 29 (2): 181–197.

Dougherty, D. 2009. The Sizzling Sound of Music: Interview with Jonathan Berger. *Radar*. http://radar.oreilly.com/2009/03/the-sizzling-sound-of-music.html. Accessed June 29, 2017.

Doyle, P. 2005. *Echo and Reverb: Fabricating Space in Popular Music, 1900–1960*. Middletown, CT: Wesleyan University Press.

Eisenberg, E. 2005. *The Recording Angel: Music, Records and Culture from Aristotle to Zappa*. New Haven: Yale University Press.

Eitan, Z., and R. Y. Granot. 2006. How Music Moves. *Music Perception: An Interdisciplinary Journal* 23 (3): 221–248.

Emmerson, S. 2007. *Living Electronic Music*. Burlington, VT: Ashgate.

Eno, B. 2004. Studio as a Compositional Tool. In *Audio Culture: Readings in Modern Music*, edited by C. Cox and D. Warner, 127–130. New York: Continuum.

Fauconnier, G., and M. Turner. 2002. *The Way We Think: Conceptual Blending and the Mind's Hidden Complexities*. New York: Basic Books.

Finelli, P. 2002. *Sound for the Stage*. Cambridge: Entertainment Technology Press.

Furchgott, R. 2007. That Warm Sound of Old in a Cold, Compressed World. *New York Times*. June 5. https://www.nytimes.com/2007/06/05/technology/circuits/05warmth.html. Accessed June 19, 2018.

Garas, J. 2000. *Adaptive 3D Sound Systems*. New York: Kluwer Academic Publishers.

Gelatt, R. 1977. *The Fabulous Phonograph, 1877–1977*. 2nd rev. ed. London: Cassell.

Gibbs, R. W. 1994. *The Poetics of Mind: Figurative Thought, Language, and Understanding*. Cambridge: Cambridge University Press.

Gibson, D. 2005. *The Art of Mixing: A Visual Guide to Recording, Engineering, and Production*. Boston: Thomson Course Technology.

Godøy, R. I. 2010. Gestural Affordances of Musical Sound. In *Musical Gestures: Sound, Movement and Meaning*, edited by R. I. Godøy and M. Leman. New York: Routledge.

Goehr, L. 2007. *The Imaginary Museum of Musical Works: An Essay in the Philosophy of Music*. Oxford: Oxford University Press.

Goodwin, A. 1988. Sample and Hold: Pop Music in the Age of Digital Reproduction. *Critical Quarterly* 30 (3): 34–49.

Goodwin, A. 2006. Rationalization and Democratization in the New Technologies of Popular Music. In *Popular Music Studies Reader*, edited by A. Bennet, B. Shank, and J. Toynbee, 276–282. London: Routledge.

Gordon, M. 2012. Mix Rescue: Rio Callahan. *Sound on Sound Magazine*. June. http://www.soundonsound.com/sos/jun12/articles/mix-rescue-0612.htm. Accessed June 29, 2017.

Gracyk, T. 1996. *Rhythm and Noise: An Aesthetics of Rock*. London: Duke University Press.

Granot, R. Y., and Z. Eitan. 2011. Musical Tension and the Interaction of Dynamic Auditory Parameters. *Music Perception* 28 (3): 219–245.

Green, J. 2011. Review of Case Studies: This Is Another Life. *Pitchfork*. June. http://pitchfork.com/reviews/albums/18161-case-studies-this-is-another-life/. Accessed June 29, 2017.

Gregersen, E. 2011. *The Britannica Guide to Sound and Light*. New York: Rosen Education Service.

Grill, T., and A. Flexer. 2012. Visualization of Perceptual Qualities in Textural Sounds. Proceedings of the International Music Conference (ICMC 2012), Ljubljana, Slovenia.

Grimshaw, M., and Walther-Hansen, M. 2015. The Sound of the Smell of My Shoes. Proceedings of Audio Mostly, Thessaloniki, Greece, ACM Digital Library.

Gross, J. 2005. Phat. In *Fat: The Anthroplogy of an Obsession*, edited by D. Kulick and A. Meneley, 63–76. New York: Jeremy P. Tarcher/Penguin.

Guberman, D. 2011. Post-Fidelity: A New Age of Music Consumption and Technological Innovation. *Journal of Popular Music Studies* 23 (4): 431–454.

Gur, G. 2008. Body, Forces, and Paths: Metaphor and Embodiment in Jean-Philippe Rameau's Conceptualization of Tonal Space. *Music Theory Online* 14 (1). https://mtosmt.org/retrofit/ mto.08.14.1/mto.08.14.1.gur.php. Accessed May 18, 2020.

Hamilton, A. 2009. The Sound of Music. In *Sounds and Perception: New Philosophical Essays*, edited by M. Nudds and C. O'Callaghan, 146–182. Oxford: Oxford University Press.

Hanson, R. L. 1930. One Type of Acoustic Distortion in Sound Picture Sets. *Journal of the Society of Motion Picture Engineers* 15 (4): 160–172.

Harley, R. 2007. *Introductory Guide to High-Performance Audio Systems*. Carlsbad, CA: Acapella Publishing.

Harper, D. 2015. Online Etymology Webpage. http://www.etymonline.com. Accessed July 27, 2017.

Hjortkjær, J. 2011. A Cognitive Theory of Musical Tension. PhD thesis, University of Copenhagen.

Hodgson, J. 2010. A Field Guide to Equalisation and Dynamics Processing on Rock and Electronica Records. *Popular Music* 29 (2): 283–297. doi:10.1017/S0261143010000085.

Horning, S. S. 2012. The Sounds of Space: Studio as Instrument in the Era of High Fidelity. In *The Art of Record Production: An Introductory Reader for a New Academic Field*, edited by S. Frith and S. Zagorski-Thomas, 29–42. London: Routledge.

Izhaki, R. 2008. *Mixing Audio: Concepts, Practices and Tools*. Boston: Focal Press.

Johnson, M. 1987. *The Body in the Mind: The Bodily Basis of Meaning, Imagination, and Reason*. Chicago: University of Chicago Press.

Johnson, M., and S. Larson. 2003. Something in the Way She Moves: Metaphors of Musical Motion. *Metaphor & Symbol* 18 (2): 63–84.

Kane, B. 2008. L'acousmatique Mythique: Reconsidering the Acousmatic Reduction and the Pythagorean Veil. Paper presented at the Electroacoustic Music Studies Network International Conference, Paris.

Kane, B. 2014. *Sound Unseen: Acousmatic Sound in Theory and Practice*. Oxford: Oxford University Press.

Katz, B. 2002. *Mastering Audio: The Art and the Science*. Burlington, MA: Focal Press.

Katz, M. 2010. *Capturing Sound: How Technology Has Changed Music*. London: University of California Press.

Kealy, E. R. 1979. From Craft to Art: The Case of Sound Mixers and Popular Music. *Work and Occupations* 6 (3): 3–29.

Kelly, E. H. 1898. *Architectural Acoustics, Or, The Science of Sound Application Required in the Construction of Audience Rooms*. Buffalo, NY: Bensler and Wesley.

Kelly, K. 2013. Review of Skagos: Anarchic, *Pitchfork*. April. http://pitchfork.com/reviews/ albums/17741-skagos-anarchic/. Accessed June 29, 2017.

Kirchin, S. 2013. *Thick Concepts*. Oxford: Oxford University Press.

Kirsh, D., and P. Maglio. 1994. On Distinguishing Epistemic from Pragmatic Action. *Cognitive Science* 18:513–554.

Knees, P., and K. Andersen. 2016. Searching for Audio by Sketching Mental Images of Sound: A Brave New Idea for Audio Retrieval in Music Production. *Proceedings of the International Conference on Multimedia Retrieval*, June 6–9, New York. DOI: http://dx.doi.org/10.1145/2911996.2912021.

Kövecses, Z. 2002. *Metaphor: A Practical Introduction*. Oxford: Oxford University Press.

Lakoff, G. 1987. *Women, Fire and Dangerous Things: What Categories Reveal About the Mind*. Chicago: University of Chicago Press.

Lakoff, G. 2008. The Neural Theory of Metaphor. In *The Cambridge Handbook of Metaphor and Thought*, edited by R. Gibbs, 17–38. Cambridge: Cambridge University Press.

Lakoff, G., and M. Johnson. 1980. *Metaphors We Live By*. Chicago: University of Chicago Press.

Larson, S. 2012. *Musical Forces: Motion, Metaphor, and Meaning in Music*. Bloomington: Indiana University Press.

Lastra, J. 1992. Reading, Writing, and Representing Sound. In *Sound Theory, Sound Practice*, edited by R. Altman, 65–86. London: Routledge.

Leman, M. 2010. Music, Gesture, and the Formation of Embodied Meaning. In *Musical Gestures: Sound, Movement and Meaning*, edited by R. I. Godøy and M. Leman, 126–153. New York: Routledge.

Levyn, T. Y. 2006. "Tones from out of Nowhere": Rudolf Pfenninger and the Archeology of Synthetic Sound. In *New Media, Old Media: A History and Theory Reader*, edited by W. H. Kyong and T. Keenan, 45–82. New York: Routledge.

Löffler, D. 2017. Color, Metaphor and Culture: Empirical Foundations for User Interface Design. Doctoral diss. Julius-Maximilians-Universität Würzburg.

Longley, E. 1853. *American Manual of Phonography: Being a Complete Exposition of Phonetic Shorthand*. Cincinnati: Longley & Brother, Phonetic Publishers.

Margolis, H. 1987. *Patterns, Thinking, and Cognition: A Theory of Judgment*. Chicago: University of Chicago Press.

Marks, L. E. 1982. Bright Sneezes and Dark Coughs, Loud Sunlight and Soft Moonlight. *Journal of Experimental Psychology: Human Perception and Performance* 8:177–193.

Marks, L. E. 1989. On Cross-Modal Similarity: The Perceptual Structure of Pitch, Loudness, and Brightness. *Journal of Experimental Psychology: Human Perception and Performance* 15:586–602.

Masters, M. 2011. Review of Water Borders: Harbored Mantras. *Pitchfork*. http://pitchfork.com/reviews/albums/15938-harbored-mantras/. Accessed May 18, 2020.

Maxfield, J. P. 1935. Some of the Latest Developments in Sound Recording and Reproduction. *Technical Bulletin*, Academy of Motion Picture Arts and Sciences. April 20, 1–8.

Menzel, D., H. Fastl, R. Graf, and J. Hellbrück. 2008. Influence of Vehicle Color on Loudness Judgments. *Journal of the Acoustical Society of America* 123 (5): 2477–2479.

Merleau-Ponty, M. (1945) 2002. *Phenomenology of Perception*. Translated by C. Smith. London: Routledge & Kegan Paul.

Michel, J.-B., Y. K. Shen, A. P. Aiden, A. Veres, M. K. Gray, W. Brockman, The Google Books Team, J. P. Pickett, D. Hoiberg, D. Clancy, P. Norvig, J. Orwant, S. Pinker, M. A. Nowak, and E. L. Aiden. 2010. *Quantitative Analysis of Culture Using Millions of Digitized Books* (Published online ahead of print December 16).

Milner, G. 2009. *Perfecting Sound Forever: The Story of Recorded Music*. Bodmin, Cornwall: Granta.

Moore, A. F. 1993. *Rock, the Primary Text: Developing a Musicology of Rock*. Buckingham: Open University Press.

Moore, A. F., and R. Dockwray. 2010. The Establishment of the Virtual Performance Space in Rock. *twentieth-century music* 5 (2): 219–241.

Moorefield, V. 2005. *The Producer as Composer: Shaping the Sounds of Popular Music.* Cambridge, MA: MIT Press.

Morton, D. L. 2006. *Sound Recording: The Life Story of a Technology.* Baltimore: Johns Hopkins University Press.

Moylan, W. 1992. *The Art of Recording: The Creative Resources of Music Production and Audio.* New York: Van Nostrand Reinhold.

Mulder, J., and T. van Leeuwen. 2019. Speech, Sound, Technology. In *The Oxford Handbook of Sound and Imagination*, edited by M. Grimshaw, M. Walther-Hansen, and M. Knakkergaard, 1: 473–492. New York: Oxford University Press.

Neyland, N. 2011. Review of Blanck Mass: Blanck Mass, *Pitchfork*. June. http://pitchfork.com/reviews/albums/15572-blanck-mass/. Accessed June 29, 2017.

O'Callaghan, C., and M. Nudds. 2009. Introduction. In *Sounds and Perception: New Philosophical Essays*, edited by M. Nudds and C. O'Callaghan, 1–25. Oxford: Oxford University Press.

Owsinski, B. 1999. *The Mixing Engineer's Handbook.* Vallejo, CA: MixBooks.

Paradis, C. 2015. Conceptual Spaces at Work in Sensory Cognition. In *Applications of Conceptual Spaces: The Case for Geometric Knowledge Representation*, edited by F. Zenker and P. Gärdenfors. New York: Springer.

Parsons, A., and J. Colbeck. 2014. *Alan Parsons' Art and Science of Sound Recording: The Book.* Milwaukee, WI: Hal Leonard Books.

Patsouras, C., T. G. Filippou, and H. Fastl. 2002. Influences of Color on the Loudness Judgement. Proceedings of Forum Acousticum Sevillia, 1–6.

Pedersen, T. H. 2008. *The Semantic Space of Sounds: Lexicon of Sound-Describing Words.* Delta. https://assets.madebydelta.com/assets/docs/share/Akustik/The_Semantic_Space_of_Sounds.pdf. Accessed May 18, 2020.

Penchansky, A., and S. Traiman. 1979. Digital Space: Spectacular Music for Films. *Billboard*, November 24, 50.

Pillow, K. 2003. *Sublime Understanding: Aesthetic Reflection in Kant and Hegel.* Cambridge, MA: MIT Press.

Pinch, T., and F. Trocco. 2002. *Analog Days: The Invention and Impact of the Moog Synthesizer.* Cambridge, MA: Harvard University Press.

Pinch, T., and K. Bijsterveld. 2004. New Technologies in Music. *Social Studies of Science* 34 (5): 635–648.

Ramachandran, V. R., and E. M. Hubbard. 2001. Synaestesia – A Winndow Into, Perception and Language. *Journal of Cosciousness Studies* 8 (12): 3–34.

Reyes, I. 2008. Sound, Technology, and Interpretation in Subcultures of Heavy Music Production. PhD diss. University of Pittsburgh.

Robinson, A. 2012. 10 Tell-Tale Signs of an Amateur Mix. *Computer Music, Special* 54:8–10.

Robjohns, H. 2000. Review of Royer R12 Studio Ribbon Microphone. *Sound on Sound*. April. http://www.soundonsound.com/sos/apr00/articles/royerr121.htm. Accessed June 13, 2018.

Roddy, S., and D. Furlong. 2013. Embodied Cognition in Auditory Display. Proceedings of the International Conference on Auditory Display, July 6–10. Poland.

Rodgers, T. S. 2010. Synthesizing Sound: Metaphor in Audio-Technical Discourse and Synthesis History. PhD diss. McGill University.

Rumsey, F. 2008. Faithful to His Master's Voice? Questions of Fidelity and Infidelity in Music Recording. In *Recorded Music: Philosophical and Critical Reflections*, edited by M. Doğantan-Dack, 213–231. London: Middlesex University Press.

Russ, M. 2008. *Sound Synthesis and Sampling.* New York: Focal Press.

Salter, L.-R. 2019. What You Hear Is Where You Are. In *The Oxford Handbook of Sound and Imagination*, edited by M. Grimshaw, M. Walther-Hansen, and M. Knakkergaard, 1:765–788. New York: Oxford University Press.

Saslaw, J. 1996. Forces, Containers, and Paths: The Role of Body-Derived Image Schemas in the Conceptualization of Music. *Journal of Music Theory* 40 (2): 217–243.

Savage, S. 2014. *Mixing and Mastering in the Box: The Guide to Making Great Mixes and Final Masters on Your Computer*. Oxford: Oxford University Press.

Saxe, F. 2001. Digital Files' Quality Suffers. *Billboard*. May 26, 77.

Schaeffer, P. 1966. *Traité des objets musicaux: Essai interdisciplines*. Paris: Editions du Seuil.

Schaeffer, P. 1967 Solfège de l'objet sonore: Grand Prix De L'academie Charles-Cros.

Schmidt, U. 2013. Det ambiente: Sansning, medialisering, omgivelse. Aarhus: Aarhus Universitetsforlag.

Schubert, E., J. Wolfe, and A. Tarnopolsky. 2004. Spectral Centroid and Timbre in Complex, Multiple Instrumental Textures. Proceedings of the 8th International Conference on Music Perception and Cognition. Evanston, IL.

Scruton, R. 1999. *The Aesthetics of Music*. Oxford: Clarendon Press.

Scruton, R. 2009. Sounds as Secondary Objects and Pure Events. In *Sounds and Perception: New Philosophical Essays*, edited by M. Nudds and C. O'Callaghan, 50–68. Oxford: Oxford University Press.

Shayan, S., O. Ozturk, and M. A. Sicoli. 2011. The Thickness of Pitch: Crossmodal Metaphors in Farsi, Turkish, and Zapotec. *Sense and Society* 6 (1): 96–105.

Simner, J. 2013. The "Rules" of Synesthesia. In *The Oxford Handbook of Synesthesia*, edited by J. Simner and E. M. Hubbard, 149–164. Oxford: Oxford University Press.

Singmin, A. 2000. *Practical Audio Amplifier Circuit Projects*. Boston: Butterworth-Heinemann.

Slepian, M. L., and N. Ambady. 2014. Simulating Sensorimotor Metaphors: Novel Metaphors Influence Sensory Judgments. *Cognition* 130:309–314.

Stefanuk, M. V. 2001. *Jazz Piano Chords*. Columbia, MD: Mel Bay Publications.

Sterne, J. 2003. *The Audible Past: Cultural Origins of Sound Reproduction*. Durham, NC: Duke University Press.

Stockfelt, O. 1993. Adequate Modes of Listening. *Standford Humanities Review* 3 (2): 153–175.

Stosuy, B. 2011. Review of Opeth: Heritage. *Pitchfork*. http://pitchfork.com/reviews/albums/15866-heritage/. Accessed May 18, 2020.

Talmy, L. 1981. Force dynamics. Paper presented at Conference on Language and Mental Imagery. University of California.

Talmy, L. 1988. Force Dynamics in Language and Cognition. *Cognitive Science* 12 (1): 49–100.

Tan, S.-L., P. Pfordresher, and R. Harré. 2013. *Psychology of Music: From Sound to Significance*. New York: Psychology Press.

Taylor, T. 2001. *Strange Sounds: Music, Technology and Culture*. New York: Routledge.

Théberge, P. 1997. *Any Sound You Can Imagine: Making Music, Consuming Technology*. Hanover, NH: Wesleyan University Press.

Thompson, E. 1995. Machines, Music, and the Quest for Fidelity: Marketing the Edison Phonograph in America, 1877–1925. *Musical Quarterly* 79 (1): 131–171.

Tiegel, E. 1966. KEZY Goal: Being Entertainment Voice. *Billboard*, November 26, 35 and 40.

Time. 1952. Columbia's Hi-Fi. 60 (25), December 22, 62.

Tingen, P. 2007a. Secrets of the Mix Engineers: Chris Lord-Alge, My Chemical Romance. *Sound on Sound*. http://www.soundonsound.com/sos/may07/articles/cla.htm. Accessed June 15, 2018.

Tingen, P. 2007b. Secrets of the Mix Engineers: Jason Goldstein, Beyoncé's "Déjà Vu" and "Irreplaceable." *Sound on Sound*. http://www.soundonsound.com/sos/apr07/articles/insidetrack_0407.htm. Accessed June 15, 2018.

Tingen. P. 2007c. Secrets of the Mix Engineers: JJ Puig—Inside the Track: Fergie's "Big Girls Don't Cry." *Sound on Sound*. November. https://www.soundonsound.com/techniques/secrets-mix-engineers-jj-puig. Accessed June 15, 2018.

Tingen, P. 2007d. Secrets of the Mix Engineers: Mark Endert, Maroon. *Sound on Sound.* http://www.soundonsound.com/sos/sep07/articles/insidetrack_0907.htm. Accessed June 15, 2018.

Tingen, P. 2007e. Secrets of the Mix Engineers: Serge Tsai, Sound Workshop. *Sound on Sound.* http://www.soundonsound.com /sos/jun07/articles/insidetrack_0607.htm. Accessed June 15, 2018.

Tingen, P. 2007f. Secrets of the Mix Engineers: Tom Elmhirst, Amy Winehouse: "Rehab". *Sound on Sound.* https://www.soundonsound.com/techniques/secrets-mix-engineers-tom-elmhirst. Accessed May 17, 2020.

Tingen, P. 2008a. Secrets of the Mix Engineers: Michael Brauer, Coldplay: "Viva La Vida." *Sound on Sound.* http://www.soundonsound.com/sos/nov08/articles/itbrauer.htm. Accessed June 15, 2018.

Tingen, P. 2008b. Secrets of the Mix Engineers: Renaud Letang, Feist: "1234." *Sound on Sound.* http://www.soundonsound.com/sos/apr08/articles/insidetrack_0408.htm. Accessed June 15, 2018.

Tingen. P. 2008c. Secrets of the Mix Engineers: Rich Costey, The Foo Fighters: "The Pretender." *Sound on Sound.* http://www.soundonsound.com/sos/mar08/articles/insidetrack_0308.htm. Accessed June 15, 2018.

van Leeuwen, T. 1999. *Speech, Music, Sound.* London: MacMillan.

Viers, R. 2011. *The Sound Effects Bible: How to Create and Record Hollywood Style Sound Effects.* Studio City, CA: Michael Wiese Productions.

von Helmholtz, H. L. F. (1875) 2011. *On the Sensations of Tone as a Physiological Basis for the Theory of Music.* Translated by A. J. Ellis. Cambridge: Cambridge University Press.

Wadhams, W. 1988. *Dictionary of Music Production and Engineering Terminology.* New York: Schirmer Books.

Walser, R. 1993. *Running with the Devil: Power, Gender, and Madness in Heavy Metal Music.* Middletown, Connecticut: Wesleyan University Press.

Walther-Hansen, M. 2014. The Force Dynamic Structure of the Phonographic Container: How Sound Engineers Conceptualise the "Inside" of the Mix. *Journal of Music and Meaning* 12: 89–115.

Walther-Hansen, M. 2016. Balancing Audio: Towards a Cognitive Structure of Sound Interaction in Music Production. In *Music, Mind, and Embodiment,* edited by R. Kronland-Martinet, M. Aramaki, and S. Ystad, 228–242. Basel, Switzerland: Springer.

Walther-Hansen, M. 2017. New and Old User Interface Metaphors in Music Production. *Journal of the Art of Record Production* 11. https://www.arpjournal.com/asarpwp/new-and-old-user-interface-metaphors-in-music-production/. Accessed May 18, 2020.

Walther-Hansen, M. 2019. Sound Quality, Language, and Cognitive Metaphors. In *The Oxford Handbook of Sound and Imagination,* vol. 1, edited by M. Grimshaw-Aagaard, M. Walther-Hansen, and M. Knakkergaard, 459–472. New York: Oxford University Press.

Walther-Hansen, M., and M. Grimshaw. 2016. Being in a Virtual World: Presence, Environment, Salience, Sound. Proceedings of the 11th Audio Mostly Conference. ACM Digital Library. 77–84.

Wapnick, J. 1980. Effects of Dark-Bright Timbral Variation on the Perception of Flatness and Sharpness. *Journal of Research in Music Education* 28 (3): 176–184.

Weber, B. 1970. The Cassette Story. *Billboard.* November 7.

Weinstein, D. 2000. *Heavy Metal: The Music and Its Culture.* Cambridge: Da Capo Press.

Wheeler, C. J. 1987. The Magic of Metaphor: A Perspective on Reality Construction. *Metaphor and Symbolic Activity* 2 (4): 223–237.

White, E. W. 1966. *Stravinsky: The Composer and His Works.* Berkeley: University of California Press.

Williams, B. 2005. Girls Gone Mild. *New York.* http://nymag.com/nymetro/arts/music/pop/reviews/15107/. Accessed August 20, 2017.

Williams, J. M. 1976. Synaesthetic Adjectives: A Possible Law of Semantic Change. *Language* 32 (2): 461–478.

Williams, L. E., and J. A. Bargh. 2008. Experiencing Physical Warmth Promotes Interpersonal Warmth. *Science* 322 (5901): 606.

Winer, E. 2012. *The Audio Expert: Everything You Need to Know About Audio.* Amsterdam: Focal Press.

Wishart, T. 1996. *On Sonic Art.* Amsterdam: Harwood Academic.

Wong, M. S. 2012. Sound Objects: Speculative Perspectives. PhD diss., University of California, Los Angeles.

Zak, A. 2001. *The Poetics of Rock: Cutting Tracks, Making Records.* Berkeley: University of California Press.

Zak, A. 2012. No-Fi: Crafting a Language of Recorded Music in 1950s Pop. In *The Art of Record Production: An Introductory Reader for a New Academic Field,* edited by S. Frith and S. Zagorski-Thomas, 43–55. London: Ashgate.

Zbikowski, L. M. 2002. *Conceptualizing Music.* Oxford: Oxford University Press.

Zbikowski, L. M. 2017. *Foundations of Musical Grammar.* New York: Oxford University Press.

Zhong, C.-B., and G. J. Leonardelli. 2008. Cold and Lonely: Does Social Exclusion Literally Feel Cold? *Psychological Science* 19 (9): 838–842.

Zinken, J., L. Hellsten, and B. Nerlich. 2008. Discourse Metaphors. In *Body, Language and Mind.* Vol. 2, *Sociocultural Situatedness,* edited by R. Frank, R. Dirven, T. Ziemke, and E. Bernárdez, 363–386. Berlin: Mouton de Gruyter.

Index

Tables and figures are indicated by *t* and *f* following the page number.

For the benefit of digital users, indexed terms that span two pages (e.g., 52–53) may, on occasion, appear on only one of those pages.